OZARK MOUNTAIN GIRL

By Wilma Groves Harryman

OZARK MOUNTAIN GIRL

By Wilma Groves Harryman

The majority of the photographs by
Townsend Godsey

Printed by Leathers Publishing
4500 College Blvd., Suite 310
Leawood, Kansas 66211
1/888/888-7696

CONTENTS

THE PHOTOGRAPHER

The photographer walked in peace;
He possessed a watchful eye;
The earth it was abound with scenes
Beneath the Ozark skies.

He went in search of things to shoot,
His camera in his hand;
He loved the beauty of the hills
That makes our Ozark land.

Each and every way he turned,
He viewed a photographer's dream.
He filmed the people and the flowers,
He even filmed the streams.

He saw a beauty everywhere;
His eyes were filled with awe;
Beauty was in the eye of the man,
And beauty was what he saw.

The hill folks seemed to love him
As he went from farm to farm;
He knew exactly what to say,
His ways were filled with charm.

He photographed the people,
He thought about their ways,
He observed the way they lived their lives
As they labored through the days.

And when he came to our house,
Our pictures he did take;
Our faces were on paper,
These treasures he did make.

They've been a joyous blessing
To all my family;
He gave my mom and dad a gift
Of immortality.

His wife, she was a blessing
To this photographer's success;
She worked beside him patiently
With her gentle helpfulness.

So thank you, Mister Godsey,
And thanks to Helen, too;
I'm thankful that I've had the joy
That came from knowing you.

— By Wilma Groves Harryman

ACKNOWLEDGMENTS

In the summer of 1941, a very talented photo journalist came to our area, whose name was Townsend Godsey. Mister Godsey was traveling through the Ozarks, going from farm to farm. His objective was to photograph the hill people in their natural way of life.

When this charming man came to our log home, he took several pictures of my family. His collection of photographs, including the ones of us, were printed in a book titled "Ozark Mountain Folk, These Were the Last." The book was published with a joint effort of Townsend and his loyal wife Helen.

This book has given my family much enjoyment. Our pictures begin on page 114 and continue through page 122.

William Townsend Godsey left this earth at the age of eighty-five, but he left behind a beautiful legacy.

I'm thankful that I became re-acquainted with the Godseys. It has been a true pleasure.

I would like to say to Mister Godsey, "While you are enjoying the glorious scenery, if you

can hear my thoughts, please know how much I appreciate your permission to use the pictures."

My thanks also goes out to Mrs. Godsey, Townsend and Helen's son Bill and their daughter, Marya Ellen (Pidge) Land.

I would also like to thank all of the Groves family and the Harryman family, and my children, Brenda, Debra, Francie and Danny, because without them this book would not have been written.

A sincere thank you also goes to my friend Tammi Renfrow and to a very dear couple, James (Denny) and Millie Dennison, for their wonderful support.

My thank you notes would not be complete without mentioning my two charges, Courtney and Christin Franke. Thanks for being there and for your encouragement.

My sister Avie and my brother Bill also assisted me with recollections of the past. Thanks to both of you.

INTRODUCTION

I was raised in the beautiful Ozark Mountains of Missouri, in and around the town of Branson. This area has changed much over the years, but there are some things not even man can ruin. The beauty of the hills is total proof of this fact.

As you read, you will realize how life was in the forties for people who were in the lower-income bracket. Unfolding for you will be a mental picture of a very special preacher and his family. You will see our general way of life and the way we had to struggle for survival. My book should be titled, "THE LIFESTYLES OF THE POOR AND UNFAMOUS."

I hope you won't conclude that I resent my background. It's only natural that I would have preferred a better way of life, but I'm thankful for the strength and appreciation that my growing years taught me.

During the era of this story, there were several personal characteristics which were necessary for survival. A few of them are: resourcefulness, ingenuity, perseverance, patience, a creative and vivid imagination and tons of energy.

My family had much in common with the early pioneers, because in both cases there was absolutely no time allotted for them to be weak or self-pitying. The income bracket we were in required us to go to bed very early and climb out of bed in the morning with the sound of the rooster crowing.

Early evening retirement had its purposes; not only was everyone completely exhausted, but it also conserved our kerosene, which we used in our lamps and lanterns.

While reading this, you will be enlightened about the way love, strength, kindness and moral support held the hand of faith.

I sincerely hope that you will enjoy reading this as much as I have enjoyed writing it.

The better part of my story is set in the beautiful Ozark hills of Missouri.

This land is abundant with the outstanding beauty of its wooded hills, meandering streams and picturesque lakes.

The panoramic views provide pictures of the scenic hills with the lakes nestled between them.

These glorious mountainous hills are decorated with many beautiful trees, including the year-'round greenery of the wild cedar and the pretty pines.

The combination of this God-given beauty produces a sight which is both pleasing to the eyes and the soul.

Springtime is an especially pretty season for the Ozarks.

After a winter of looking at the trees that have been stripped of their green garments, it is very nice to watch them slip into their summer clothing.

Spring is the season for the wonderful red-buds and dogwoods to bloom, and the rolling hills are alive with a wide assortment of wild flowers.

My father referred to this eye-catching scene as "God's flower garden." His favorites of the wild blossoms and flowers were the dogwoods.

It is obvious that Daddy wasn't alone with his appreciation of the dogwood trees, because it is Missouri's state tree.

When the dogwood trees are all in bloom,

the beauty which they provide will fill your heart with an admiration for God's talents.

A legend that floats around the Ozarks goes as follows:

At the time of Jesus' crucifixion, the dogwood tree grew as large as an oak tree. The strength of the tree encouraged the choosing of its lumber to be used for the cross. The poignant legend goes that while Jesus was hanging on the cross, he vowed that the dogwood tree would never again be used for such a cruel purpose. So from that day forward, this beautiful tree would grow too small for the making of a cross. The petals would form a cross, and at the edge of each petal would be a resemblance of a partial nail print stained with blood, and the center of the flower would resemble a crown of thorns.

When I think of the humiliating torture that Jesus suffered on that mournful day, it's very comforting and satisfying to hope that this legend could possibly be true.

It's a well known fact that the Ozarks are appreciated by many thousands of people. There is no need to wonder that they attract so many tourists. To see the Ozarks is to completely fall in love with them.

Long before Table Rock Dam was completed and before the many attractions on 76 Highway (now known as Country Music Boulevard) were developed, an astounding amount of people visited the Ozarks.

This particular area of Ozark Mountain Country is blessed with three beautiful lakes, from whence came the title, "The Tri Lakes Area." Table Rock Lake is well known for its bass fishing, of which it holds a wide assortment, such as large mouth, small mouth, white bass and Kentucky bass. It also has the rock bass (goggle eye), two species of trout, the rainbow and the brown. Also, in the spring the white and black crappie and the channel catfish lure in the fishing people.

The lake running between Branson and Hollister is Taney-como. This lake is known for its trout fishing, and its name was derived from the state and county in which it is located, Taney-CO (County) and MO (Missouri), TANEY-CO-MO.

Bull Shoals Lake, flowing from Forsyth, Missouri into Arkansas, is also known for several different species of bass.

Yes, for someone with fishing in mind, this area is a true paradise.

An expression of Spring is made
with the dogwood blossoms.

SPRING

I think to choose a season,
My favorite would be
The one before the summer,
Spring's beauty thus to see.

The daffodils are bowing
In their yellow dressed attire;
The trees are donning all their clothes
In green we all admire.

The dogwoods bring forth blossoms
Of pretty pink and white;
Their beauty they will share with us
In wonder we delight.

The birds are giving songs of love;
They sing a song of spring,
A lilt they're giving to our hearts
True joy their songs will bring.

The bluebells turn to say good-bye,
Dressed in their skirts of blue
To winter's chill they nod their heads
And bid a fond adieu.

— By Wilma Groves Harryman

THE OZARK HILLS

The misty hills lie bold and still
Beneath the evergreens,
Their restful beauty lying there
To flatter lakes between.

In spring the hills become a sea,
Flower beds of sheer delight,
Reflecting beauty on the land
With radiant colors bright.

The sun hangs low in western skies,
Prepares to draw her shades,
Then stars are used to pin them closed
To seal the end of day.

In wooded oaks I hear the sound
Of evening whippoorwills,
Their sounds unique to offer us
More beauty for the hills.

— By Wilma Groves Harryman

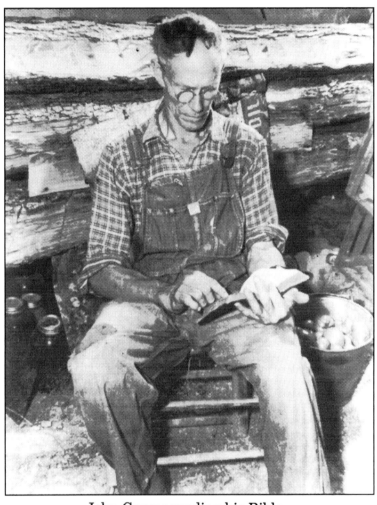

John Groves reading his Bible,
after a long day in the tomato fields.

Chapter 1

MY FATHER

To some he was "Preacher Groves," to others he was "Brother Groves," to my mother he was "John," and to his children he was "Dad."

My father was a remarkable man. During his sixty-two years of living, he contributed much guidance, love and kindness to the world. He was a devoted husband, father and preacher, and my mother was ever faithful, loyal and true. She was Dad's rock-steady companion and helper. Whether it was in church, in the fields, in our home or where and when she was needed, she was always there. She was in every way the true spirit of the pioneer woman. I was very fortunate to have such a nice set of parents.

As you read my story, you will realize how very dedicated, loving and caring my parents were. The respect which people showed them was totally and completely earned.

As a dedicated preacher to his faith, my father lived his life as a testimony to the people. He enjoyed his experience in our Lord so very much that he wanted everyone to share it, so he worked, prayed and lived with so much Christian love that one couldn't fail to see it.

Within the Blue Eye vicinity, he pastored the Bowman Church for several non-consecutive years. Quite often we walked to church, but if we decided to go in style, Dad would harness up our team of old work horses (sometimes an old mule was used as a fill-in). He would hitch them to the same wagon he used to haul tomatoes to the canning factory, and to bring the stripped sugar cane from the field to the sorghum mill. This wagon was used for so many things that it had more personality than most people. Dad never learned to drive, which was just as well, because he wouldn't have been able to afford a car — not to mention the gas to run it.

Yes, our money was almost as scarce as snakes' hips. Dad didn't believe in collecting an offering for himself. His belief was, "If one works for God, one shouldn't ask for payment for this service." Our means of livelihood was extremely limited, so we learned to be very frugal.

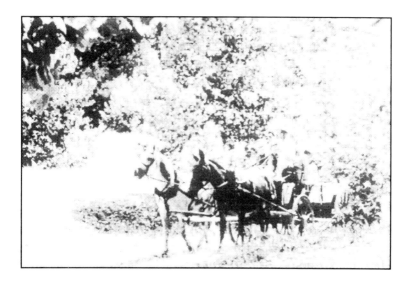

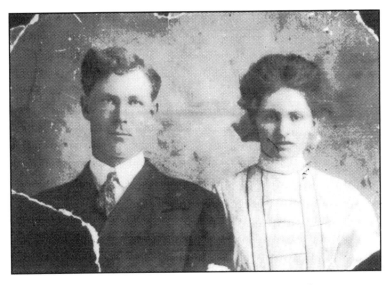

John and Mary Groves on their wedding day,
June 17, 1909

Chapter 2

THE GROVES CLAN

Before moving to the Branson/Blue Eye area, both of my parents lived in El Dorado Springs, Missouri.

Please permit me to now backtrack to the time before my parents were married.

John Daniel Groves was a young man of seventeen when he met Lula Garland. In those days, before a couple became wed, a certain amount of courting time was necessary. I doubt if my dad went past the typical time period which was acceptable, before he and Lula were married.

Their wedding was performed on October 7, 1901.

They had been married ten months and five days when on August 12, 1902, their first and only son was born. On January 15, 1904,

Howard was followed by Mary Elizabeth (Meke). Their second daughter came into the world on February 28, 1906. They named her Jocie.

The union between John and Lula was shortened because Lula died just two months short of six years after their wedding day.

Lula's death was due to a very difficult delivery with Jocie. She never gained back her health and strength the way she should have after the birth. She gradually became weaker and weaker, and on August 16, 1907, Lula Garland Groves passed away.

Poor Lula, only twenty-two years of living and her life was over. No doubt her last thoughts were of her husband and three children.

At the age of twenty-three Dad must have been devastated. He was then a widower with three small children to love and care for and protect. Oh, how difficult it must have been to be both father and mother and also the bread winner. But knowing my dad, I'm sure he did his very best.

On October 14, 1908, only fourteen months

after Lula's death, my father suffered yet another loss. Baby Jocie was only on this earth for one year, seven months and fourteen days, before she joined her mother in Heaven.

Eight months after Jocie died, on June 17, 1909, my father, who was still a young man at the age of twenty-five, married my mother, Mary Frances Amos. To this marriage would come eleven children.

Mary Frances Amos Groves was then an instant mom. Seventeen years of age and the stepmother of a seven-year-old son and a five-year-old daughter. She must have been quite a woman even then.

I'm sure these two people, at the time of their wedding, had no idea that they would always struggle for survival.

I imagine I would be safe in saying at this time her style of living was comparable to the way I remember.

Just one year, one month and eleven days after my mom and dad were married, on July 28, 1910, my mother gave a painful birth to her first son, Asa Amos.

On November 23, 1912, James Daniel was born, "Dan" for short.

My mom and dad's third son, John Etna, was born on May 1, 1914. He lived only six months and twelve days.

A few days after John Etna's death, my mother was lying in bed, and she saw two stars appear on the ceiling. Until later, Mom had no idea what the stars meant.

On May 23, 1915, just six months and ten days after the death of John Etna, Mom gave birth to a stillborn baby boy. On January 21, 1917, just shy of twenty months later, a second stillborn son was born. Neither child was named. I have often wondered why.

After giving birth to the two stillborn babies, Mom was sure that the prophecy of the two stars on the ceiling had been unfolded to her.

My parents' sixth son, Louis Ezra, was born on May 17, 1919.

On October 14, 1922, their seventh son came into the world. He was named Perry Lee.

My mother once told me she thought she was

never going to get a girl, but on April 2, 1925, Naomi Ruth was born.

My parents' second daughter joined the family on February 27, 1928. She was given the name Grace Avenell, but she would be most known as Avenell or Avie.

The second to the last, my brother Bill, was born on April 22, 1931.

Bringing up the rear (no pun intended) on April 10, 1936, I was born, Wilma Ilene. Mom said she felt like naming me "Edith Ann Enough." My brother Bill is guilty of giving me the name Wilma." I've often wondered if he was ridding himself of the frustrations of having the middle name of "Sylvester." Then a second thought told me, maybe he was afraid that Mom would name me Edith Ann Enough.

Now to reflect for a moment about the night of my birth. I was told that it was raining buckets on April 9, 1936, when my mother's labor pains began. She knew the time had come to bring her eleventh child into the world. She counted the minutes between the labor pains to be sure she wasn't being premature. She then sent my brother Asa to fetch our midwife

(or granny-lady). Asa rode his horse through the pouring rain to bring Lydia Burnett to our little house.

I made my appearance on April 10, 1936, at one o'clock a.m. Poor Mom! At the age of forty-four she had used the best years of her life having babies and nursing them, and then she had a little blonde, curly-haired, squaller on her hands to nurse and care for. It's a wonder she didn't send me back, but I came with a note saying, "non-returnable."

My birth certificate states:

Wilma Ilene Groves
Date of Birth: 1 a.m., April 10, 1936
Birthplace: Blue Eye, Missouri
County: Stone

Blue Eye was about fifteen miles from where we lived, but it was our closest township. It is a little country town situated on the Arkansas line and is literally on the line because a section of the small town is in Arkansas. The post office is on the Missouri side, so the town is known as a Missouri township.

While growing up, I heard several stories about why Blue Eye was given such an odd

name. One of the reasons was the postmaster had one blue eye and one brown eye. In which case, why did the blue eye take precedence over the brown?

Nevertheless, I'm going with the story that Blue Eye was named for its first postmaster, Elbert N. Butler, who, I'm told, had two blue eyes.

This small town is set in the middle of God's country, which is Ozark Mountain Country. It's about fifty-five miles south of Springfield, Missouri. Springfield is known as the Gateway to the Ozarks.

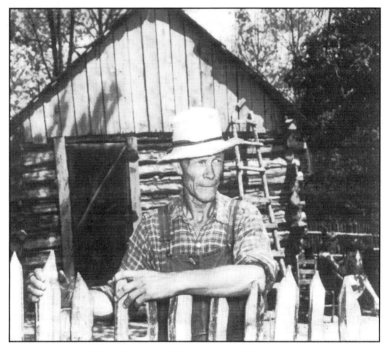

John Groves: "Our way of life is poor,
but in God's love we're rich."

Chapter 3

OUR LOG HOME
1940

Growing up in the Ozark Hills of Missouri was a unique experience for me.

My first collective memories dwell within the era of when we lived in our log home.

With the help of three of my brothers, Asa, Perry and Bill, my parents built the log cabin. Their structural materials consisted of logs, mortar, a saw, hammer, nails, and lots of patience, grit and sweat. Just to think of the amount of back-breaking toil that went into the building of that two-room cabin totally exhausts me.

The work began with going to the woods and cutting the trees. At this point, it was important to find as many of uniform size as possible. Following the cutting of the trees, they were then trimmed of all of their branches. The logs were then dragged to the building site. They were

cut to the correct length, and notches were cut about six or seven inches from the end of the log to aid with the stacking.

Mortar was slathered between the logs to hold them together. Mortar is usually made by mixing cement, lime, sand and water. I daresay Daddy was forced to substitute dirt, wood ashes and dried grass for the aforementioned binding agents.

In those days, people did most of their building in the summertime. This was a plus in finding the grass, although we never had a shortage of dirt. The wood ashes were taken from a pile that had collected from the cleaning of the stoves, and we carried the water in buckets.

When the logs were stacked to the sufficient height, the making of the roof began. Rough boards were nailed to the two-by-four studs that served to shape the gables. Crude wood shingles were nailed into place, and the gable ends of the house were covered with boards. A rough board floor was laid, a small window for each room was put into place, and the home-made doors were hung. The hinges for the doors were made of old tires. Dad cut the tires open and cut a semblance of squares to be nailed into place to hold the doors in position.

Our fashionable new home was early hill-billy and a bit crude, to say the least. Needless to say, we had no modern conveniences but, as a shelter, it sufficed.

The next order on the list of creating was building the bathroom. What an awesome sight — this one-room shanty was ventilated with the cracks in the walls and door.

The john was always located an acceptable distance from the house, for sanitation purposes. We had to decide to go to the bathroom before we needed to, because if we waited too long, we would have to run or Mother Nature would completely lose her patience. I believe this is one of those fond memories one might choose to forget.

In the summer, the outhouse was much like a sauna. And we came out of there weighing less for more than one reason.

During the winter months, I would get so cold my teeth clattered together. At times such as this, I was happy to be made of tough Ozark stock. I would just "grin and bare it," and when I was finished, I went into the house with two sets of red cheeks.

Our discarded catalogs served a dual pur-
pose. They were our wish books, as well as our
toilet paper. I'm afraid the delicate softness
wasn't there, but they were much better than
corn cobs. If one looks hard enough, one can al-
ways find something for which to be thankful.

Sitting there thumbing through the catalogs,
I dreamed of living in a nice home and of hav-
ing all the beautiful things that were owned by
people of means.

Here in our home away from home, the wood
ashes were again useful. When sprinkled on
the waste, the ashes helped delete the odor.

Even after all these years, I'm thankful to
have an indoor toilet to use, because memories
of the old two-holer are still "strong" in my mind.

When the john was finished, the interior of
the cabin was put into place.

First things first; Mother Nature holds a
precedence over comfort.

In the space where a kitchen sink might
have been, sat a small cabinet holding an old

galvanized dishpan. Our bathroom sink was an enamel wash pan resting upon a little table. The bathtub was my mom's washtub, and the indoor toilet was a lidded white chamber pot. The pot was used only at night, so Mom referred to it as "The White Owl." When morning came, the first job on the list was to carry the White Owl to the outdoor toilet and dump it into one of the holes.

A few hours later, if one was in dire need of entertainment, we could stroll behind the toilet and watch the dung beetles, hard at work. In the Ozarks, these beetles are known as tumble bugs.

These gross little scarabs would make their collection and roll it around with Ozark tumble bug pride. Now I ask you, "Who needs a television set with this sort of entertainment available?"

When the tumble bug felt her ball of waste was of sufficient size, she rolled it to her den and laid her eggs in the warm defecation. When the baby scarabs hatched, they fed off the same waste.

Living in a two-room cabin with five other

people was at times a bit tricky.

At this time, Dad and Mom had only four of their combined family still at home. The cabin was shared by my parents, my two sisters, my brother Bill and myself.

It was sort of like working a jigsaw puzzle to get all of us bedded down at night. Yet another reason to go to bed so early, this way Mom had enough light to see how to fit the pieces together. Yep! It's the only way to start the day, to awaken with your sister's toes in your face. If you've never slept at the foot of the bed, you're missing something, although I've learned to live without it.

That cabin was quite the humble abode. During the winter months, it was like living in a refrigerator. Our old wood stove was kept stoked and fed, and during the day the cabin stayed fairly warm. But at night, when the logs burned to embers, the cabin became so cold our nostrils froze together. Then Mom or Dad would climb from under all those quilts and stoke and feed the stove again.

In the hottest summer months, our little home changed into a different appliance. To say it was comparable to an oven is to put it mildly.

We had no electricity with which to power fans, so there were times when the heat was next to unbearable, especially when the mercury climbed to the top rung of the ladder.

I guess we were lucky that there were only six people trying to live in such a small area. One more person and it would have been necessary to hang them on a nail or stand them in a corner. As it was, we had to back up to get out of each other's way.

It was probably a blessing that my older brothers married so young. But on the other hand, I imagine they were glad to get away from the crowd. Although the cycle goes on, because they turned around and made their own crowd with their children.

Asa and Perry and their families usually lived only a short distance from us.

Dan did a lot of evangelical work; consequently he and his family were usually not around us.

During the era of the log cabin, Ezra was in the Army. Howard earned his living by doing farm work, and he lived with the people for

whom he worked.

Meke married Johnny Pace and moved to Mexico, Missouri, where they would raise their family.

This left Naomi, Avenell, Bill and me, the only siblings remaining at home.

I was always much happier when my family lived nearer to us because my nieces and nephews and I were so close in age, we spent many fun-filled hours playing.

We owned precious few toys, so our imaginations were compelled to work overtime.

One of our toys was an old abandoned automobile tire. We rolled the tires around and around, pretending they were pretty cars.

We also spent a lot of time playing with the well-known stick and hoop. We could usually find an old keg hoop lying about, and the stick was either a board or maybe even a small tree limb with a flattened can nailed to the end of it. This device was used to roll the hoop around. It really isn't as easy as it sounds. A certain amount of dexterity and coordination

was necessary to be an accomplished hoopster.

In the wintertime, the snow-covered hills are wonderful for sledding. Did we allow the lack of authentic sleds to deter us from the snow fun? No way!

We simply went in search of an old cardboard box. Of course, the bigger the box the better. We flattened the box into a snow disc substitution and went flying down the hills. What fun!

Another great snow toy was a toy wagon bed. The local garbage dump would usually furnish us with this luxury. By the time the wagon bed found its way to the dump, the wheels were usually gone anyway, so we used this discarded object for a sled replacement.

In the summer we spent many happy hours playing in the creeks and rivers. Then, of course, there were the pretend funeral and church services.

Yes, improvisation serves many purposes when you're poor as church mice.

Sketched by my grandson,
Austin Harryman Worden

Chapter 4

OUTDOOR PLUMBING

Plumbing pipes and water faucets were just two of the many luxuries our cabin did not provide, although nature was a friend to us with the water supply she furnished.

At the corners of the cabin, wooden barrels were placed to catch the precious rain water, which we would sparingly use for many purposes. I think one of the most appreciated usages for this gift from the Heavens was for washing our hair. It served as a conditioner and made our hair soft and manageable. If we were out of rain water when we needed it for our hair, we simply used creek water or spring water and added vinegar to soften it. The vinegar substituted as a conditioner and an anti-dandruff aid. Oh, how we improvised! It is truly amazing how many things one can live without if it's a must.

For dishes and laundry our rain water was

also appreciated because the softness of it was an aid in the lathering of the lye soap. Of course, we didn't use the valued water for these purposes unless we had an over-abundance of it.

It didn't seem to matter where we lived, Mom always managed to find a fresh water spring.

She would use a flat object, such as a board, or a flat pan, to clean the spring bed. She removed the moss and rocks and other alien substances which had collected in the spring.

The spring was cleaned periodically so that our water would be clean and pure.

From the spring we carried water for many uses such as drinking, water for cooking, and if the rain water supply was depleted, we carried the spring water and sometimes creek water for our other water needs.

We carried our buckets to the water's edge, and being extra careful not to stir up the soil and gravel in the spring or creek bed, filled our buckets.

The adults used a three-gallon galvanized bucket, but my water utensil was a one-gallon syrup bucket. I sloshed water all the way home, and if I was lucky, I may have gotten home with a whole quart.

Carrying the water gave us yet another reason to pray, this time for rain to lessen those trips for water, and also our crops and gardens depended solely on the rain for irrigation.

During the hottest summer months, we used our spring for an icebox. In the water, we placed such items as milk, butter, watermelon, etc. This was a short-term preservation procedure.

When necessary, we even used the spring water for our sponge baths and Saturday washtub baths. But carrying the water was such a bother during the warmer months, we took advantage of the creeks and rivers for bathing.

Chapter 5

NATURE'S KITCHEN

The Ozark heat prompted us to do most of our summer living outside the cabin.

During these sweltering months, Mom cooked all of our meals on an old wood-burning stove, which stood in the yard under a big shade tree. A short distance from the stove sat a table and chairs. This was truly nature's dining room and kitchen.

This area was busy much of the time because we not only used the table and stove for eating purposes, but Mom also used them for canning.

Mom canned everything she could get her hands on. This was not only necessary, but mandatory for our winter survival. She canned fruits, vegetables, meats, jams, jellies, juices, pickles and different types of relishes such as chow-chow. Chow-chow is made with a combination of grated raw cabbage, chopped green

tomatoes, chopped onions, peppers, vinegar, water and spices. This relish was an excellent topping for our pinto beans, which was our basic protein supplement.

The foods that were served on that table were quite southern and somewhat different from a menu viewed by city folks.

Our day began with a hot breakfast. We sometimes ate hot cornmeal mush served with a little molasses or wild honey and milk if we had it; if not, then we ate it without the milk. If there was leftover mush, it was poured into a greased shallow pan to become firm enough to slice for frying. This served as a good breakfast the next day. A little molasses or wild honey dribbled on the fried mush slices, and once again our palates were saying, "Hooray for southern cooking!"

Biscuits and gravy was and still is a favorite for many people. The milk gravy was deliciously seasoned (if we were lucky enough to have meat drippings); otherwise lard was used to mix with the flour for a seasoned thickener. The men in my family loved their biscuits and milk gravy (or fliggum, as they referred to it).

Red-eye gravy is another good biscuit sopper.

It's made with meat grease (preferably ham), water is added to the grease instead of the milk, and flour. Greasy, but a sufficient substitution for the milk gravy.

My mother's fried green tomatoes would almost melt in your mouth. They made a delectable appetizer and in many cases a side dish. To prepare the tomatoes, Mom sliced them and dipped the slices in a mixture of beaten egg and milk. Then they were dipped in salted flour and fried in hot fat until they were a crispy brown. If there was a shortage of eggs and milk, salted flour sufficed for the tomato coating. The fried green tomato recipe was also used for several other foods, such as wild mushrooms, fried chicken, pork chops, squash and eggplant.

We thoroughly enjoyed our fried foods, not only because they were delicious, but cholesterol was something about which we knew nothing. If you're not aware of it, how can you worry about it? The arteries may have clogged, but the taste buds jumped up and down with satisfaction.

I'm sure most people will agree with me when I say, "Nobody cooks as good as Mom." I

loved to watch my mother cook, especially when she made pies. To me it was fascinating to watch her roll out the crust, fill the pie shells with delicious fruits, add the top crust with the pretty design she had cut in it, and flute the edges of the crust to perfection. The pies were then baked in the oven of the old wood-burning cook stove. I've since wondered how Mom ever regulated that oven well enough to bake anything, let alone pies.

After watching the delicate work that went into the pies, I would collect the discarded canning jar lids that Mom had given me and prepare to make my mud pies (I can still remember how good the warm mud felt as I squished it between my fingers). I then shaped my pies in the lids and turned them out onto a flat surface to dry. While they were still moist, I decorated them with wild flowers and tiny leaves. I must say, even at five, I showed culinary talent.

When Mom cooked beans in her old three-legged cast iron bean pot, I copied her. A lady named Mrs. Perkins gave me a little cast iron pot. It looked exactly like Mom's, except it was only an inch and a quarter in diameter. I still have it sitting in my kitchen.

Mom also made our sauerkraut for canning.

With her work-worn hands, she used her favorite paring knife with the blade worn thin from over-use and many, many sharpenings. She patiently cut the cabbage away from the core. She then ran the raw cabbage through a manually operated meat grinder. The core of the cabbage was saved to be placed in the center of the canning jar before she finished filling it with freshly ground cabbage. Many a sauerkraut maker thought they couldn't make good sauerkraut unless they put the ground cabbage in a large crock before putting it in the jars. My mom's kraut always turned out great with the method that she used. The sauerkraut was also another mouth-watering food served with pinto beans.

Blackeyed peas, or "blackeyed beans" as they are known by some, is another of my favorite southern foods. They have a flavor all their own, and I think one must acquire a taste for them.

Hominy ... my goodness! When Mom made hominy, I couldn't wait until it was ready to eat. The aroma that came from the corn while it was cooking made me so hungry. This delicious delight is made with field corn, yellow or white. After removing the corn from the cob (shucking the corn), the corn kernels were

soaked in a lye solution to soften them. This also serves to loosen the hulls from the corn. After the corn had soaked in the lye solution for a sufficient amount of time, it was then washed thoroughly to remove any traces of the lye.

The corn was sometimes cooked before it was put in the jars, but the most successful canning process for hominy was to just "cold pack" it. For this canning process the corn was put into washed and sterilized canning jars and sealed. The jars were then placed in a large kettle with cold water around them. The pan was placed on the stove, and to prevent glass breakage the water was heated along with the filled jars. This canning method ensured freshness and served as a preservative for many foods such as tomatoes, vegetables and meats, to name a few. The cold pack unit was an effective substitution for the pressure cooker — which, of course, we didn't have.

Each spring a large vegetable garden was planted. From this garden came vegetables to sell and to can. All summer we ate fresh foods from the garden. Mom canned what we couldn't eat, for our winter use.

Dad and Mom planted the seeds and shoots, then watched and hoed them religiously. I remember balking when I was told to help in the garden — I think I was a bit lazy, but I was more than happy to help enjoy the harvest when all that good food was placed upon the table.

Now on to the subject of beans. Without this substantial staple, starvation would have been biting at our backsides in a much more severe manner. There were the lima and the butter beans, the navy beans, the pinto beans and the green beans. While growing up, I ate an abundance of this wonderful legume and never tired of them. One of my favorite meals continues to be: pinto beans, cornbread, fried potatoes, and a wedge of raw onion. "Mercy, that's good eatin'!"

I learned to enjoy the beans without the benefit of ham because, more often than not, we didn't have the ham to throw in.

This combination of southern foods provided our systems with protein, carbohydrates and grain. And I'm sure this meal gave us a bit more than the daily allotted fat grams that our bodies require.

Most southern people refer to the mid-day meal as dinner and the evening meal as supper.

Quite often, the main meal was cooked at lunch time and everyone gathered 'round to enjoy. They came from the fields and the woods or wherever their toils had taken them.

The meal was savored, then they allowed their stomachs to rest a bit before going back to their individual tasks.

The leftovers from the noon meal were stored and served for supper. Preparing the big meal at lunch time was an excellent time-saving tactic, and it also prevented the leftovers from being wasted. Leftovers were much enjoyed in our family.

One of my dad's favorites was leftover cornbread. He would crumble the bread in a bowl or a canning jar and pour milk over it. I remember him saying to my mom, "Mary, do we have any cornbread? I'll just have cornbread and milk for supper tonight." Mom's answer was, "Yes, we do, John. We ain't got much else but what'll fill up'll fatten."

Another way Daddy enjoyed the cornbread was to smear our homemade molasses on it. We

always had plenty of molasses. I'll explain why a little later in my story.

Honey was another blessing for the cornbread. We felt very fortunate when Dad went into the woods and robbed a bee tree. The honey was much appreciated by all, because we grew very tired of sorghum molasses.

The honeycomb was not to be taken lightly either, because for us it was quite a treat to chew the comb until all the sweetness was gone.

From the time I was old enough to hold a glass jar without dropping it, I helped churn butter. I don't remember a time when we owned a churn. Our butter churn was a canning jar.

Mom poured the cream into the jar, tightened the lid and said, "Shake, daughter." I did, but she said she meant the jar.

I shook the cream until butter formed and separated from the buttermilk. Mom then removed the butter from the jar and put it in a bowl. She used a fork to mash all of the milk out of the butter. A little salt was added, and

the fruits of my labor was ready to be eaten. Another plus for the cornbread.

The buttermilk was enjoyed as well. Dad loved to drink it with meals.

The jar-shaking process of churning was as effective as the hand-turned churn and provided more exercise. I suppose this could also be a good form of frustration release.

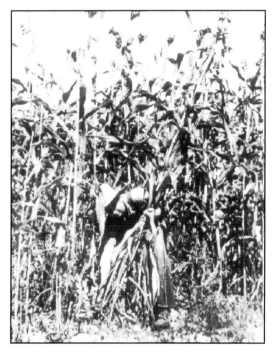

Cutting and stripping the cane

Chapter 6

SORGHUM MAKING

To know my parents was to know that the only cane they ever raised was sugar cane. They grew large fields of the cane to be used for the making of sorghum molasses.

When the harvest time came, the family worked together to cut and strip the cane of all its leaves. Then the stalks were bundled and hauled to the sorghum mill. Daddy located the mill as close to the house as possible. This offered convenience in several ways: the molasses didn't have to be carried very far after being poured into containers. Also, the cooking process was quite lengthy, so if Dad got thirsty, the house was close enough for him to run and get a drink of water.

I suppose the mill could have been considered "a community mill" because it was shared by neighbors. It was passed around so much, they probably forgot to whom it belonged.

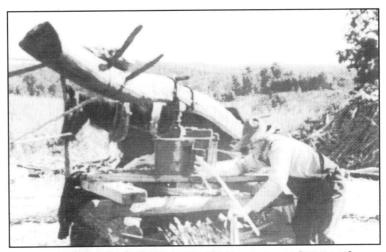

To feed the cane into the mill can become a tedious task.

Each individual furnished his own stand for the mill. The construction of the stand was quite crude and simple. If memory will permit, I will attempt to describe the making of the stand. Using his man-powered saw, Dad would cut six logs to approximately five feet in length and six more to approximately three feet in length. The logs were stacked, alternating the length with the width. Then boards were nailed on top of the stacked logs. This allowed the mill to sit more level, and it also added support.

The stand was then ready for the mill to be placed on top of it. This required some extra muscle power from whomever had a strong enough back and happened to be nearby.

The sizes of mills may have varied, but to the best of my ability I will describe the one we used.

In actuality it wasn't as big as one might imagine, but it was very heavy because it was made of cast iron. The size of the mill was about three and a half feet wide and about two and a half feet high.

The mill contained openings through the sides. The openings housed iron rollers.

After situating the mill on top of the log stand, my father was off to the edge of the woods. In his work-worn hands, he carried his trusty axe. His mission was to cut a tree to be used for the sweep. The tree he was searching for would be about ten inches in diameter at the base, and it was advantageous if the tree was a bowed or bent tree. After cutting the tree, all the branches were then removed. With the help of the work horse, the tree was dragged back to the mill site. Mission accomplished, Dad's sweep was almost ready to be placed across the top of the mill. A hole needed to be drilled in the tree so it would fit on the large bolt which was located at the top of the mill. This bolt was connected to the gears. Then it was time to tie the horse to the small

end of the sweep. A rein was fastened to the horse's harness. The tugging action of the rein encouraged the horse to stay in motion. The horse pulled the sweep around and around. The pulling action of the sweep activated the rollers which pressed out the sugar cane juices.

On one side of the mill sat a large container to catch the juices. On the other side, the cane was manually fed or pushed through the mill. Over by the fire sat a large cooking pan. When the primary container was full, it was emptied into the large pan. When the cooking pan was full enough, it was placed on the open fire to begin the cooking process.

I remember watching my father as he stood

Carrying the cane to the mill

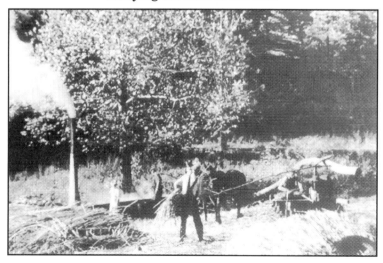

patiently over the hot fire. As the juice cooked, it formed a foam on the top. As the foam began to form, Daddy would skim it off and then stir and skim some more. At times, it was obvious he was lost in thought. He was probably thinking about the people who would benefit from the molasses, including his own family.

The longer the syrup cooked, the darker and stronger it became. If the cooking process was stopped while the molasses was syrupy but still a lighter color, the sweet gooey mixture was more mellow tasting.

At intervals, while Daddy cooked, he would move away from the pan for a moment to relieve himself of the heat and to take his handkerchief from his pocket and wipe his perspiring brow. Then back to the stirring and skimming until the molasses was cooked to the perfect stage.

When the molasses was cooked to my father's specifications, it was poured into containers for cooling.

Dad sold the molasses in one-gallon syrup buckets. The price was one dollar per gallon. If a person came to our house needing molasses but wasn't able to pay for it, Dad gladly

gave it to them.

It was just another ordinary day for the Groves family. Work at the sorghum mill was proceeding as usual. Then the ordinary day became something almost indescribable.

Mom looked up to see some people coming to buy some molasses. She was feeding the cane through the mill, when the lady came over to talk to her. Mom stopped work temporarily to chit-chat for a while. While chatting with the lady, Mom absent-mindedly laid her arm on the mill, and the sweep came around and broke it. Dad could not perceive the possibility of such an unusual accident, so he asked, "Mary, how did you do that?"

In the process of showing him, she used her good arm to lay the broken one on the mill. You guessed it, the sweep came around and broke it in yet another place.

At that moment, my mother must have felt so stupid, inadequate and embarrassed. Poor darling. In my mother's defense, I have to say she was embarrassed quite often, but she was neither stupid or inadequate.

This silly mistake could have been brought about by a number of things, perhaps the excitement of having a friend to talk to, maybe the reprieve from work for a few minutes, or maybe it was because she was just simply so exhausted that she wasn't thinking.

Mom pardoned herself from appearing stupid in this incident by verbally guiding Dad and the lady friend through the tedious task of setting the bones and placing the splint (homemade cast) on her arm.

The splint was made of thin boards, which were probably taken from the kindling pile. The boards were placed lengthwise on her arm and tied securely in place with fabric strips. This was not a pretty sight, but my sweet mother's arm healed with no complications.

During her convalescent stage, she didn't sit around and wait for her arm to heal. Her work continued as usual; it was just performed a little slower. She said, "I'll get over it before I'm married twice," and she did. She got a lot of mileage out of that story though, and she always chuckled when she told it.

Chapter 7

OUR CLEANSING PRODUCT

Have you ever considered what it would be like to use a soap for washing dishes, doing laundry and yes, even bathing — a soap that was so harsh that it hardly lathered?

Such was the case with my family, because my mother made our soap with lye, grease and water.

To begin the making of this cleaning product, Mom took the bacon grease and other meat fats that she had saved and melted them together. The grease was mixed with water and boiled to eliminate the salt. The grease was then skimmed off the water. The next step was to mix the lye with cold water. The skimmed grease was mixed with the lye mixture, and the cooking process began. (If lye wasn't available, wood ashes were substituted.)

The mixture was cooked slowly. The amount

of time the soap was cooked determined its strength and harshness. A shorter cooking time caused the soap to be strong and harsh. A longer cooking time produced a milder soap. It also became lighter in color when cooked longer. It was very nice when Mom had the time to do this because it was much more pleasant to use for bathing. It was really nice when she added extracts from flowers to the soap, although this was a luxury we didn't often have. Probably because of the time element and the availability of flowers.

When the soap had cooked to the specified amount of time, it was poured into a flat container to cool. Before it had reached its firmest stage, Mom cut the soap into bars. Then it was allowed to finish cooling before it was stored.

The milder soap was used for washing our hair, as well as for bathing. This was still stronger than the bath bars of today.

Quite often when I'm using a nice smelling shampoo or bathing with a nicely scented bar of soap, I remember the lye soap. I have to believe that the lye soap acted as an exfoliant on our bodies. It nearly took the skin, why wouldn't it remove the dead skin cells as well?

We were lucky we didn't have alligator skin.

When using the lye soap, you actually worked up a lather getting a lather. No matter how hard you worked, the soapy bubbles were limited. This fact was discouraging, although the soap appeared to serve its cleaning purposes.

Mom's washing machine was a washboard and a galvanized washtub. I wonder if she considered herself lucky that she didn't have to beat our clothes on a rock to clean them.

The water had to be carried and heated. Mom filled the tub with hot water, stood the washboard into the tub, slapped the clothing item onto the washboard, rubbed the lye soap across the soiled item and scrubbed it up and down, until it was clean.

Lord, what an awful job? Mom had a name for her washboard, she called it "the knuckle bruiser." It's quite an experience to do laundry for a big family using a washboard. It certainly would cause one to appreciate their automatic washer or their maid, depending on their financial status.

Chapter 8

HOMEMADE ICE CREAM

During the summer months, we always lived so far off the beaten path that we could not buy ice, although we wouldn't have had the funds with which to buy it anyway. Consequently, the only time we were lucky enough to enjoy scrumptious homemade ice cream was in the winter time.

If we had snow on the ground, we simply gathered clean snow in a bowl, added sugar, a small amount of milk and vanilla extract and stirred well and enjoyed. But this wasn't the best recipe. The ice cream that we really enjoyed came from a joint effort of Mom and Dad.

Dad's first errand was to go searching for ice. He usually found the ice hanging on the sides of bluffs. Big, thick icicles just waiting to be plucked, to be used for our wonderful delicacy.

Sometimes Dad found the ice hanging on large

rocks or maybe even resting on a pond. It didn't matter to us where he got it, as long as he got it.

While Dad was gone to get the ice, Mom prepared the ice cream mixture. She beat the eggs, then added the milk, vanilla and sugar. The mixture was then cooked until it was of the right consistency to coat a wooden spoon. When the stirring and cooking process was completed, the delicious liquid was ready to be poured into a one-gallon syrup bucket. This container was tightly lidded and placed inside a three-gallon bucket.

Dad then broke the ice into small pieces and alternated the ice and salt in layers around the one-gallon syrup bucket. The layering continued until the freezing combination reached the top of the smaller bucket. A thick cloth was used to hold the handle of the gallon bucket, and the freezing of the ice cream began. Dad turned the bucket back and forth, back and forth, until it was time to check the contents.

He had made ice cream in the "Poor Man's Freezer" so many times, he knew exactly when to check the freezing progress. The reason the next procedure was necessary is because of the lack of a paddle inside the bucket for which to stir the liquid.

The lid was wiped clean and carefully opened. Using a dinner knife he scraped the sides of the bucket and stirred the mixture well. This procedure was continued until the wonderful dessert was frozen solid.

I watched Dad closely as he turned and checked. I didn't want to miss the opening and stirring because he always gave me a sample taste. Between tastes, I waited impatiently for him to open it again. Without that taste test, I would have experienced a very difficult time of waiting.

When it was finally ready, the lid was removed for the last time, and the delicious contents were served.

We gathered around the old wood-burning heater, as close as we could get without burning ourselves. We shivered and spooned and spooned and shivered until the bowl was empty and again refilled.

While eating this delectable treat, the headaches came easily. This was such a rare treat for us we couldn't resist eating it a little too fast. This didn't alter our enjoyment of the sweet delight which had been prepared with such tender loving care.

ENDURANCE

My life as a child was filled with need
And lack of self-assurance;
We wandered the hills and low creek banks
In search of our food allowance.

We searched and hunted and scrambled
*　　　through briars*
For edibles to fill our larder;
Finding these foods was an absolute must,
Or our future days would be much harder.

Somehow we managed to persevere
Through sickness, sadness and sorrow;
It seemed with grit and love and faith
We saw a bright tomorrow.

I know my life was different from
The children of today, and
A choice gift from my parents was
To appreciate in every way.

— By Wilma Groves Harryman

Chapter 9

A MOTHER OF NATURE

My mom, what a woman! With the exception of the eleven times that she was pregnant, she never weighed a hundred pounds, even when she was soaking wet. As small as she was, she could push a plow as well as a man. She sewed most all of our clothes. This tiny woman drove nails like a true carpenter and performed all the duties and tasks that were expected of a pioneer woman. Yet she had the dexterity and patience to remove a splinter from your hand or finger with the precision and delicacy of an experienced surgeon.

Mom was familiar with everything that grew wild in the woods, whether it was edible or not.

I remember tramping through the woods with her, while we searched for the wild foods to fill our cabinets. They would be not only for our immediate use, but many of them could be

canned or dried for our winter needs.

As I tell you about these foods, I will also explain how they were used.

One of the wild fruits that we picked was the wild huckleberry. This small berry has the same appearance as the tame blueberry except it's smaller.

Mom canned the huckleberries for us to eat as a fruit, but she also used them in pies, cobblers, jellies and jams.

Gooseberries ... personally I never acquired a taste for these tart green berries. They were put to the same use as the huckleberry and the wild blackberry.

In my book, the wild blackberry was a different story. Maybe you've heard the old saying, "The harder you work for something, the better it will be." That little quote might have been started by a wild blackberry picker. This plant is of the rose family, and the vines are just as prickly, except they're finer. My hands resembled blue pin cushions after helping Mom pick the valued blackberries. This berry is also smaller than its genetic derivative, the tame

blackberry, but more enjoyable because the seeds are smaller.

Added to the other uses this berry provided was juice to can for drinking. Many people made wine from the juice, but not my family. Our faith was very much against the drinking of fermented beverages.

I looked forward to collecting the wild persimmons. They were not only delicious, but they also provided me with free toys. You see, the seeds in this small fruit resemble tiny eating utensils.

As a child, I was taught that the persimmons required a visit from Jack Frost before they were fully edible. The frost alleviated the bitterness from this fruit. We enjoyed eating them fresh, as well as the goodies that Mom made from them, such as jelly, bread and cookies.

I must not forget the wild strawberry. These were just a tease. They were so small and sparse it seemed to take forever to find enough for a good taste. If you could find one as large as the end of your thumb, you felt very lucky. Nevertheless, they were delectable, sweet little berries.

Mom looked forward to the wild greens in the spring time. I believe she thought these were one of God's medicines for cleansing the system. There are many varieties of wild greens, and Mom knew all of them. A few are purslane, wild lettuce, lambs-quarter, poke-salad, deer-tongue, sour-dock and wild mustard.

A deliciously wonderful tea is made with the sassafras root. The roots needed to be dug in the spring, before the sap left the roots and traveled up into the tree.

After the roots were dug, they were rinsed free of all the excess dirt. Then they were scrubbed clean and simmered to make a tea which tasted a lot like root beer. Not only was this tea very pleasing to the taste, but it was a system cleanser and a diaphoretic (a perspiration inducer). It was also drunk to reduce the swelling of the feet. The smaller sprigs from the sassafras tree or bush could be chewed to cleanse the teeth and gums. Allegedly the tea also promoted healthy skin.

In recent findings, it has been stated that the sassafras root contains carcinogenic agents. To repeat one of my former statements, "One doesn't worry about what one doesn't know."

Due to this fact, we thoroughly enjoyed our sassafras tea.

Another springtime delicacy that we enjoyed was the spongy-looking morel mushrooms. These are elusive little devils. Their color blends with the soil so they are somewhat difficult to spot. They are found in a very moist area, usually on the eastern side of an old tree trunk, a dead log or just any place that would produce fungus.

In the fall we enjoyed the large coral mushrooms. These are of a coral color and actually resemble one of the reef corals from the sea. Another tasty treat, but not quite as good as the morel.

Another tasty treat, but not quite as good as the morel.

An oddity we enjoyed was the sheep sorrel root, which is like a tiny sweet radish. This was another tasty little morsel.

The search for paw-paws also took us into the woods. I remember finding them on creek or riverbanks. The moisture from the water beds encouraged their growth. The paw-paw grew on hillsides as well, but more often than

not we found them by the water beds, so we looked there first.

The paw-paw tree is of the custard apple family. The blossoms are a reddish-violet color, and the fruit, at its ripest stage, is almost the color of an over-ripe banana. In fact, when I was a child, we didn't get bananas very often, so the paw-paw was a delicious substitution. This wild fruit is also known as a custard apple or an Arkansas banana.

It was necessary to pick this fruit soon after it had begun to soften. The ripening process could be completed at home. However, we often waited too long for this procedure, and by the time we found them they had fallen to the ground, and it was rare if we could get to them before the squirrels, raccoons and other wildlife feasted on them. They enjoyed paw-paws as much as we humans did.

The paw-paw was not only delightful fresh, but it could also be enjoyed in breads and jam.

Over the years, with the clearing of land, the paw-paw tree has been destroyed. Some have escaped the culprit bulldozer, but these trees aren't nearly as plentiful as they were when I was a child.

Mom also took advantage of nature's bounty with the making of a remedy for the common cold. From the woods she gathered the wild horehound plant, and from this plant she concocted a candy that satisfied the sweet tooth, as well as a soothing comfort for a sore throat.

We never bought cough syrup; it was considered to be medicinal. Our faith disapproved of medicines, but my mother's home remedies were accepted because they were all natural.

Mom gathered the horehound plant, took it home and washed it thoroughly. She gathered as much of the plant as she could find so she would have enough to dry for later use.

To make the candy, Mom thoroughly washed the horehound plants. The leaves were removed from the stems and added to water to simmer. When the water and leaves had simmered an appropriate amount of time, the liquid was drained from the leaves. To the horehound tea Mom added lemon extract (which she had bought from the traveling Watkins Man). To the lemon extract and liquid, honey was added. If Dad hadn't robbed a bee tree of late, molasses was substituted. The combina-

tion was cooked to the soft ball stage and poured into a greased pan. After it was allowed to cool, the candy was broken into small pieces, and our cough remedy was ready.

Mom was thankful if she had honey to use because it was more effective for coughs and sore throats, but she was great at improvising. We often suffered a sugar shortage, and the molasses was a good substitution for the honey. Daddy's homemade molasses served faithfully as a sugar replacement.

I have always had a powerful sweet tooth; consequently, the horehound candy tasted rather good to me. As a child, I had access to very few sweets, so the candy provided me with a cough remedy as well as a treat.

The first time I saw Mom prepare her tooth-ache remedy, I was truly amazed.

She busied herself with building an outdoor fire, and from the wood pile she took a green hickory log and laid it on the fire. When the log became very hot, sap began to drip from the end of it. This is where Mom placed a cup to catch the sap as it dripped from the log. It was

a must that the log be hickory; no other wood held the same soothing effect that this particular wood provided.

After collecting the sap, Mom used a spoon to drop the liquid onto the aching tooth. This is quite extraordinary because it really works.

But then, of course, believing in my mother was probably half the battle. Then, too, tender loving care goes a long way.

There were so many wonderful things that my mother collected from the woods, things that made our lives better. Many moons have passed since those days, so I'm sure there are many I have forgotten. But there are two things I will never forget … the ticks and chiggers. Quite often during our search for food in the woods, we collected as many of these as we did food, sometimes more.

You're right, Mom had a home remedy for this, too. For this purpose, the wild plant penny-royal was gathered. Mom washed and simmered the plants to get a tea; the tea would be used for an insect repellent. It's too bad we seldom thought to use it before going into the woods. Nevertheless, it was later used on the

itchy bites as a soothing wash.

For the repellent and the wash, a very mild tea was necessary because the penny-royal could be very harsh to sensitive skin.

A stronger solution could be used on dogs and cats to repel fleas and ticks.

Chapter 10

SURVIVAL

Country people perform a variety of tasks to subsidize the family income. My family was no different. One endeavor of survival was the large fields of tomatoes that we raised each year.

In order for the tomato crop to grow and thrive, we planted the small tomato plants and prayed for rain. While they were growing, we hoed and weeded and prayed for more rain. When the crop was ready to be picked, the family joined together in this hot, itchy job. (We had more than our share of togetherness.)

The tomatoes were carefully placed in wooden crates for transfer to the canning factory. They would be sold to the George Dodgen Canning Factory in Blue Eye, Missouri. Dad hauled the tomatoes to the factory in his transport truck, which was the same old well worn wagon that we used to go to church. The horse-

power for this backwoods vehicle was his team of old work horses.

En route to the factory, Dad patiently guided the horses over the rutted country roads. Pot holes were abundant then. If you hit a hole or a rut, your teeth were nearly jarred loose. In this blessed vehicle, there was no cushiony shock action, and there was a very good chance that he would either be bruisin' or losin' his tomatoes.

After arriving at his destination, Dad would climb down off the wagon and help unload his cargo. When this job was finished, Dad would visit for a while (maybe throw in a little preachin'), collect the money for the hard-earned load, then head for home. When he got home, hot and tired, he might read his Bible for a while, or as was often the case, go straight to another task, for the purpose of our survival.

In those days children were expected to earn their keep, and most kids did. I know we did. Although I might have used the word "we" a bit loosely, I was a little young to be of much help, and when I tried, I'm sure I was more in the way than I was help. But my brothers and sisters certainly did their share of all the hot,

dirty jobs that needed to be done.

Sometimes when we picked tomatoes, we used the over-ripe ones to remove the stains from our hands. During the cleanup we usually couldn't resist the urge to throw a rotten tomato or two. They generally hit their target because we were often not far apart. One time Bill threw a tomato that wasn't so rotten that it would splatter, and it came to rest on Naomi's nose. My dear sister looked like a clown with the red tomato fastened to her nose. This was the closest that we ever came to a circus. Lighthearted, fun moments such as this helped to break the monotony of the day.

Chapter 11

A STITCH IN TIME

My parents lived with the faith that if they were in dire need of something and it was a need that they couldn't help themselves with, the Lord would provide.

Sometime during the era of the log cabin, solid proof came along that this belief worked for them.

Dad was in desperate need of white shirts to wear to church, and I'm certain he wasn't looking forward to wearing feed sack shirts. To my parents' delight, a large box came in the mail. In the box were several white shirts. The shirts were in good condition, except the collars were frayed. The lady who had sent the shirts was a long-time acquaintance. This thoughtful person knew Mom would have the knowledge to repair the shirts.

My mother didn't have the useful tools that

seamstresses own today. Her stitch cutter was a razor blade, which she put into action on those shirt collars. Mom removed them, turned them over and sewed them back onto the shirts. One couldn't detect the difference from Mom's stitching and the factory's. My father was so happy about this, he said, "God must have put it in Sister Jones' head to send the shirts." His faith never waned.

The next Sunday morning, my father donned one of the newly repaired shirts and his best dress slacks, and my mother wore her best "Sunday-go-to-meetin' " polka dot dress. No doubt Naomi, Avenell, Bill and I wore flour sack clothes, although I think Mom ordered Bill's overalls from one of our mail order catalogs.

We were dressed in our finest and ready for Sunday School and church. This particular Sunday we walked to our little church.

The services proceeded, and when we were walking home, Mom said, "John, that was one of the best sermons I've ever heard you preach. But why did you stand in the corner the whole time?" To which my dad replied, "Well, Mary, I think you would have stayed in the corner, too, if you'd had the whole seat of your pants ripped

out."

My father was a serious man, but he had his humorous moments.

The thread in the aforementioned pants was probably rotten. But Mom sewed the pants, and he wore them a while longer.

It seemed to me that my mother could make or repair just about anything. I believe the old adage, "She could make a silk purse from a sow's ear," was true of my mother. She was so talented.

Mom never used a pre-fabricated pattern. She measured the person for whom she was sewing and made her pattern from a newspaper or whatever she could find. As I ramble through this story, you'll read more about Mom's talents.

Mom sewed all the items that she worked on with an old Singer treadle sewing machine. She got a lot of use out of that machine, and she kept it tuned up so that it purred like a kitten. She was adept in the knowledge of sewing machine repair. Ladies from miles around came to get my mother to repair their machines. Mom was referred to as "the sewing machine doctor."

Mom was not only a doctor of sewing machines, but she was a talented Granny Lady as well. She not only delivered babies for neighboring ladies, but for her family, too.

With the new mother's painful and weakened condition and also the crying of the infant, another of Mom's home remedies came in handy. One of the alley cat's favorite treats was a blessing at times such as this (wild catnip).

Mom gathered this plant which grows in the woods. She thoroughly washed the plants and brewed them into a soothing tea.

When the fresh tea was given to the new mother, she was able to rest and sleep better. Another advantage the tea had was the tranquilizing effect it bestowed upon the new arrival when it was breast fed.

The catnip could be gathered and dried for later usage. After the drying process, the dried plants were stored in air-tight containers.

A favorite Granny Lady story of mine was

given to me by a dear lady by the name of Bessie Taylor, who was present at the time Mom was preparing to deliver a baby. The pregnant lady was a very small woman. This fact had Bessie worried. She was fearful that the tiny lady would experience a difficult delivery. Mom put Bessie's mind at ease by saying, "Ah, don't worry, Bessie, a hole in a keg is the same size as it is in a barrel."

I sincerely hope you share my feelings for the humor in this story and don't think that it is too awfully crude and tacky.

When Bessie told me this story, she was in her eighties, and she was so cute when she told it.

I'm sorry to say, Dear Bessie isn't with us any more. But, Bessie, I hope that you're visiting with my beloved mother in Heaven.

SACRED FOOD

The Bible was his food for life,
His strength and guiding light;
He read it faithfully with love
Each morning and each night.

— By Wilma Groves Harryman

Chapter 12

GENEROSITY

One of the many things that I loved about my daddy was his giving nature. I think he could easily have been referred to as "a philanthropist to the poor, by the poor." He truly loved helping people. To share anything he had with a person who needed it was one of his greatest joys. Dad lived faithfully by the quotation, "It is more blessed to give than to receive."

Another of Dad's favorite quotations from the Bible is, "If thou wilt be perfect, go and sell that thou hast, and give to the poor, and thou shalt have treasure in Heaven, and come and follow me." This verse is of Jesus speaking and is found in the New Testament, Saint Matthew, Chapter Nineteen, Verse Twenty-one.

I don't resent my father for being a generous man. Instead I respect him for living as he believed.

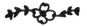

My father, what a special Dad he was. He was such a gentle, good man. On occasion he was too gentle for his own good. For example, Mom wielded the rod in our household. There was no "Spare the rod and spoil the child" with us. She got her message across loud and clear, and we respected her for keeping us in line.

We respected Dad, too, even though the toughest he ever got in the punishment area was when he punished one of the boys by whipping him with a necktie. Talking to us was very effective for him. When he talked, we listened. He had a way of saying exactly the right things to make us want to do what he asked.

MY PARENTS

My daddy was a preacher,
My mother was a wife;
We lived in Ozark country
Most all of my young life.

Our house it was a cabin,
Our kitchen was a yard,
Our car it was a wagon
'Cause times were very hard.

We lived on beans and taters,
Cornbread and biscuits, too;
We lived our lives in poverty;
We seldom got things new.

My parents always taught me
To be good in every way;
The way of life they gave me
I remember still today.

I'm thankful I had parents
Who taught me to do right;
They lived their lives with hope and faith;
They strived with all their might.

Sometimes when I am sleeping,
In dreams my dad I see;
My mom is also in my dreams,
They're there to comfort me.

— By Wilma Groves Harryman

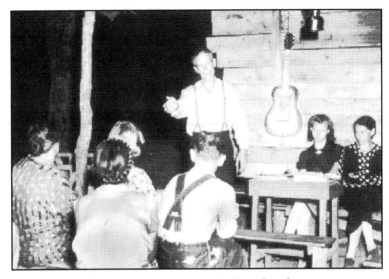

A reverent sermon in the brush arbor

Chapter 13

THE BRUSH ARBOR

During the hottest summer months, church services were held in a brush arbor. I'm sure most of you know about this outdoor church. But just in case you're not familiar with them, I will attempt to describe this structure of "down home architecture." The entire construction was quickly done and very simple. Dad was assisted by the same three brothers who helped with the log cabin. Some of the members of my dad's congregation donated their time and efforts as well.

The assemblage of the brush arbor began with the laying of a rough board floor to serve as a stage. At the back of the stage a small backboard (or wall) was built. Against the wall sat a handmade bench for the Bible reader and the lead singers. A pulpit was situated in front of the bench directly in the center of the stage. The pulpit in this case was rather different because it was a hand-made, mustard yellow

table which had been brought from home. At this table my daddy stood to deliver his sermons. During the colder months, the table was taken home, and it was used to hold a kerosene lamp and Dad's Bible. Now that was a sacred table.

The altar was placed in front of the pulpit, and the next step was to erect the frame. Here again, trimmed trees were used for the tall posts. Forked branches were left on the trees, and still more trimmed trees were laid across the tops of the trees where the forks were left.

Some sort of wire (probably chicken wire) was stretched across the top and fastened to the horizontal logs. The wire served as a bed for untrimmed tree branches, which provided shade for Sunday morning and early evening services.

To complete the brush arbor, the wood benches were made. The materials for these consisted of logs, boards and nails. The logs were sawed to approximately fifteen or sixteen inches in height. Boards were then nailed to the top of the logs and the seats were finished. Not very comfortable, and I must say, one dared not squirm too much or you could have easily gotten a mean splinter in the derriere.

The people who came to our church weren't bothered by things such as this because comfort wasn't a big issue. They were there for the reason they should have been, to serve God.

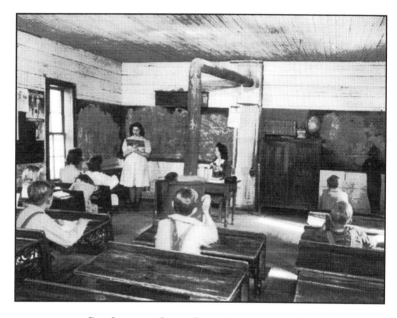

Grades one through eight were taught
in this typical country school.

Chapter 14

EDUCATION

When I was a child, education didn't come easily. At the time that we lived in the log cabin, we walked to school. It was a one-room log building.

Grades one through eight were all taught in the same room. This particular school of which I'm speaking was known as "Brush Creek," which is now under Table Rock Lake.

My teacher's name was Millie Snowden. A wonderful Christian lady, whom I admired a great deal. Millie lived with students' families, alternating the time. She helped with housework for room and board. For her classroom duties, state funding allotted something like fifteen to twenty dollars a month.

When I was in the first grade, one particular day comes to mind. I decided to leave my seat and go sit with my sister, Avenell. I sim-

ply couldn't resist the temptation to open her ink well. My small fingers had a difficult time removing the lid. The jar slipped from my hand, and ink spilled all over the front of my dress. But it didn't stop there. Avie received her share of the blue liquid as well. I was so embarrassed, the only thing I could think to do was to go to the outhouse and hide. That was where I stayed, with my five-year-old humiliation, until Miss Snowden came looking for me with her tactful consolations. You have no idea how very much I appreciated the gentle way she handled the situation. She was definitely a teacher to remember.

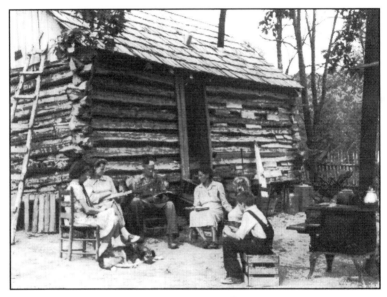

Prayer meeting at home,
on a no-church night.

Chapter 15

OUR PRAYER MEETINGS

We were in church several nights a week, and when we weren't in church, we had prayer meetings at home. Yes, I can truthfully say, "I was raised in church."

When the prayer meetings were in progress, the hills and hollers were alive with the sweet sounds of praying and singing. These were normal events in those days.

I think the prayer meetings were designed to free our hearts and souls from the toil and stress of the day and to aid in giving us strength for the next day.

These meetings were sort of a condensed version of our regular church services. Dad read the Bible, Avie played her mandolin, while Naomi strummed her guitar and we all joined in the singing of the glorious hymns. These soul-strengthening meetings ended in prayer.

Our old dog "Queen" was also religious after Avie taught her to pray. Avie would say, "Pray, Queen," and obediently, Queen would place her paws in front of her, lower the front part of her body and whine. Now this is perfect proof that dogs go to Heaven.

THE PREACHER, THE MAN

The preacher with his Bible,
The pages worn with use;
He walked the hills and preached the word,
His faith forever new.

I watched him as he moved about;
A prayer was in his heart,
A man of strength and love and faith,
From sin he kept apart.

A family man, a preacher,
A worker of the fields,
His crops of sacred labor
In abundance thus to yield.

How I loved this man of God,
To me a gentle giant;
His inner strength was obvious
To aid His will in pliance.

If by now you wonder
Why I loved this dear man so,
You see, he was my daddy,
His love has helped me grow.

A Tribute to My Father
"John Daniel Groves:
— *By Wilma Groves Harryman*

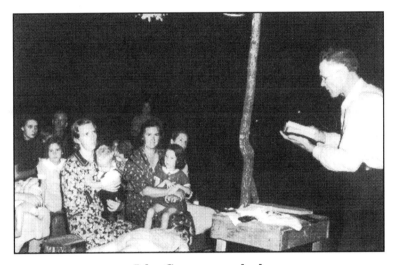

John Groves preached
with honesty and conviction.

Chapter 16

OUR CHURCH SERVICES

As a child, our meetins', as we referred to them, seemed to me, to be a bit lengthy.

I'm sure they seemed much longer to me than they did to the adults.

Before I describe one of our typical meetins', I would like to say that I have always resented having Free Pentecostal people referred to as "Holy Rollers." In our church, no one ever rolled around on the floor.

The church services began with prayer. The next segment of the services was the song service — my favorite part. How I enjoyed listening to the sweet sounds of "Amazing Grace" and "The Old Rugged Cross." These two songs continue to be favorite hymns of mine.

The song service was followed by the testi-

mony service. The preacher would either invite someone to lead this service or ask for a volunteer. The leader would stand behind the pulpit and give their testimony; then they would ask, "Now who will be next to give praise to our Lord?"

When all the people who wished to testify had stood and told about their love for the Lord and about all the things he did for them, the special songs were then heard. The minister would invite certain people who sang well to do a special number. If their voice was a little lacking in talent but the preacher knew they loved to sing, they were invited anyway.

I was a perfect example of this kindness. When I was invited to sing, I was elated, although my performance was somewhat unique.

I walked up on the stage and, immaturely and impolitely, turned my back to the congregation, then I belted out the song. I can't remember why my manners went astray at this time, but I think it was due to bashfulness and maybe not wanting to know if someone laughed. Then, too, I was only five years old.

I loved to sing, but I'm quite sure I awakened the coyotes in the neighborhood when

with my raspy little voice I sang out the melody.

My sisters both sang these special numbers, accompanying themselves with the guitar and mandolin. Their voices blended nicely. Avenell's alto voice harmonized beautifully with Naomi's soprano.

My mother often sang solos, but on occasion she enjoyed having us accompany her.

THE BASHFUL SONGSTRESS

She walked upon the splintered stage,
The tow-head bashful girl;
She chose a place to stand and sing,
The little girl with lively curls.

She turned her back to everyone
For laughter that she feared;
If they made fun, her hazel eyes
Would misty up and tear.

Position set, she tuned her chords
And opened up to sing,
And when the high notes she did scream,
The people's ears had cause to ring.

A cappella was her way,
The notes she didn't know,
But when she hit that octave range,
It caused her face to glow.

And when her song had ended,
She turned and bowed so sweet,
Her performance was completed,
The little girl with tattered feet.

— By Wilma Groves Harryman

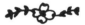

His prayer was sacred and full of love.

My father's sermon was next on the agenda. Mom would sit on that hard bench behind the pulpit and read the Bible for him while he preached. She read until he held up a hand, signaling that he was ready to speak about the verses that she had read. He then took the scripture and explained it in his own sweet spiritual way.

Sometimes he spoke only a short while about the pre-read scripture, but more often than not, his message would get quite lengthy. Dad preached with such honesty and conviction, he could bring the vilest sinner to their knees.

He believed and preached a very strict way of life, but he practiced what he preached, without flaw.

As Dad was winding up with his sermon, I was winding down. But I sat like a lady and listened intently, until my eyelids began to grow heavier and heavier. Then on the same handmade bench where I had been sitting, I made my bed, closed my eyes and dreamed of hell-fire and brimstone. A while later through semi-awake ears, my father's sweet voice would slip into my head and tell of how Jesus loved the little children. That's all I needed for my heart and mind to be totally comforted.

When the sermon was concluded, the altar call was performed.

Dad would ask the congregation if anyone was present who felt that their soul wasn't right with God.

Songs were sung such as:
"Just as I am without one plea
And that thy blood was shed for me
And that thou bidst me come to thee;
Oh, Lamb of God, I come — I come,"

and

"Come, ye sinner, lost and hopeless,
Jesus' blood can make you clean,
For He saved the worst among them
When He saved a wretch like me."

During this segment, the singing was much softer than it was in the previous part of the service. One might say it was background music for my father's sweet beckoning voice, saying, "Come and let your soul be cleansed from sin."

When all the troubled souls had knelt at the altar, Dad, along with the other Brothers and Sisters, would gather 'round and help these people pray through to salvation.

The new converts didn't need to join the church. The word "Free" in Free Pentecost means, when one has given their heart and soul to God, their name is automatically written in "The Lamb's Book of Life" in Heaven.

The next step for the new converts was to be baptized.

The baptizings were held on a Sunday, and depending on the amount of new converts, usually after a revival. When a revival was held, we were in church every night of the week. And they often lasted two or three weeks.

Riverbank Services preceding the baptizing.
The author as a child, seated next to her mother
who is wearing the polka-dot trimmed dress.

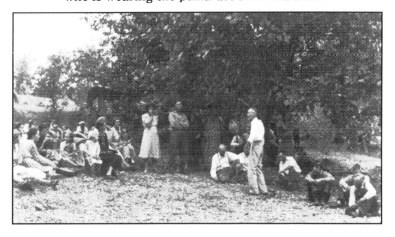

Church services also preceded the actual baptizing. These special services were held at the riverbank or creek bank. While we were living in the log cabin, the most accessible and suitable water for this purpose was Long Creek, which has now blended with Table Rock Lake.

The pre-baptismal services weren't as long as our regular church services, but I was all for condensing them, because I was required to sit still, and the heat was usually intense.

When the pre-baptismal services were completed, all the people who would be baptized joined hands. My father led them to the creek where one by one they were taken under water to have their final sins washed away. Before Dad took them under, his prayer was, "In the name of the Father, the Son and the Holy Ghost."

These moments were very spiritual and sacred. The man in the baptismal picture, who is without a shirt, was there because he had taken a dare, but my father treated him no differently than anyone else. He firmly believed that we are all God's children and whether converted (saved) or not, God still loves us.

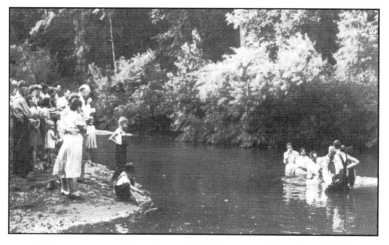

After a person has given their heart and soul to God,
the baptizing provides a final cleansing of the soul.

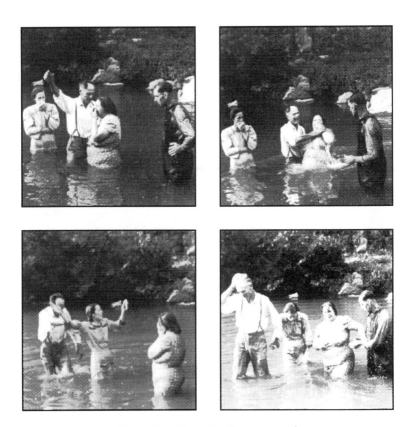

"I baptize thee, in the name of
the Father, the Son and the Holy Ghost."

Chapter 17

OUR SOCIAL LIFE

The old-fashioned Free Pentecostal Faith required a very strict way of life; consequently, other than church, our social life was quite limited. Dances, movies or anything in this category were considered "too worldly." Church was the center and outer ranges of our lives.

Perhaps it was our lack of social activities which prompted me to look forward to the "all-day meetins' and dinner on the ground." I have no idea where the aforementioned term originated. I can only assume at some time they actually spread the food onto the ground, as in picnic fashion. But as time passes, even small things such as this changes.

The term "all day meetin' " was completely accurate because the church services continued intermittently all day.

The tables for the food were assembled thus:

a few of the men would carry six to eight church benches into the church yard and situate them under shade trees. The benches were lined up, the same amount on both sides. Boards were lain across the backs of the benches to serve as the table top.

If these functions had been held at my dad's church, the dinner would have been served on the lower benches because we didn't have backs on our benches. But the services were generally held at the larger churches because these gatherings weren't scheduled very often, so they were well attended.

Now to describe the wonderful country buffet which was prepared for this occasion. Each lady brought her own specially prepared foods, as well as her own tablecloth. After the tablecloths were spread over the simulated tables, each lady decorated the long table with her cuisine of home cooking. There was always an overabundance of delectable foods. Covering the long tables were a variety of meats, fried chicken, vegetables, different types of potato salads, as well as several kinds of other salads, cakes, pies, cookies and many other foods and desserts too numerous to mention. Favorites of mine were the fish cakes and deviled eggs. I was also quite partial to the dessert section of

the table.

The ladies of the church loved these spiritual gatherings, and these events provided them with an opportunity to socialize, exhibit their culinary talents and to share recipes.

With the exception of occasionally attending a funeral, this was probably the social event of the season.

A descriptive scheduling of the day is as follows: the services began much the same as usual, with prayer, singing and, of course, preaching. Preachers came from near and far to share fellowship with their Brothers and Sisters of the Lord. The Ministers took turns preaching, and between the sermons hymns were sung by a variety of people.

I lived with the hope that the service would break after each sermon. The break would give us kids a chance to play games and to simply get away from the preaching for awhile.

We youngsters were required to sit quietly through the services, and for a child who doesn't understand half of what they're saying, those sermons would get quite boring. After four or five of those, I was thinking, "Sorry,

Lord, enough is enough, I'm hungry, let's eat."
You see, my thoughts kept drifting back to
those long tables, which I knew would be
loaded with all those delicious delights.

When the final morning sermon was fin-
ished, the noon-time meal was ready to be
eaten. We all gathered around the table and a
prayerful thanks was given and the hymn
"Come and Dine" was sung. All of our plates
were filled, and we thoroughly enjoyed the
spiritual bounty.

After everyone had finished eating, they
rested and visited for a while before the ser-
vices were continued. The preaching, praying
and singing were then carried to the supper
hour.

About six o'clock, a closing prayer was said,
and once again we gathered around the table.
After eating and more jovial visiting, the ser-
vices were continued well into the evening
hours.

When the youngsters began to get sleepy, we
simply found an empty church seat, stretched
out on it and went to sleep.

About ten-thirty or eleven, the services

would come to a close and the children were all awakened. When everything had been loaded into the wagons, Model A's and old pickup trucks, we all went home with our tummies full and our tails adraggin'. But everyone's heart was a little lighter due to the spiritual strength and guidance they had received from the services.

Chapter 18

WPA AND THE RATIONING

During the depression, Dad worked for WPA (Works Progress Administration). This program was established in 1935 by Franklin Delano Roosevelt. The program was authorized by Congress for emergency relief. Five million dollars was set aside for this program which provided work for many jobless people.

While on this program, my father helped plant many of the older pine trees in the Lampe and Blue Eye area. The pines are very beautiful and to me they have a special meaning and quality. My special enjoyment of them stems from knowing that my daddy's hard-working hands helped to add this long-lasting beauty to the area.

As we all know, times were very hard for many people during the depression. But times were hard for my family all the time, so with us, the depression didn't really make a lot of

difference. We were as poor before and after the depression as we were while it hovered like a black cloud.

During World War II, many things were rationed. The government issued each household a certain amount of stamps for each rationed item or product. Some of the rationed items were automobiles, tires, gasoline, shoes, sugar, nylon and tobacco.

For each item purchased, a person was required to submit the correct stamp and the cash value of the product.

The rationing program was necessary because of supply not meeting demand.

Programs such as WPA provided more jobs, thus people had more money to spend. Consequently, they purchased more items than before. The armed forces needed many of these products, so manufacturers were unable to produce enough of the products and items to meet everyone's demands. Thus the rationing system.

The fact that sugar was rationed made our

molasses very useful. It was appreciated, not only by my family, but many, many other households as well. Even though the molasses satisfied my sweet tooth, I never truly learned to appreciate the flavor of this thick, gooey syrup. But a sugar junkie will settle for anything sweet.

The shoe shortage didn't affect us a great deal. We didn't buy new shoes often enough to even use all of our rationing stamps. During the summer months we went barefoot a lot, but I can't remember ever being without shoes in the winter months. Somehow my parents always managed to keep us shod when we needed it most. Our shoes might not have been the best or the latest style, but they kept our feet warm. We were very lucky to have parents who tried so hard.

During this time my brother Ezra, who was in the Army, sent me a pair of little red shoes. Those were the grandest and prettiest shoes I ever saw, and they were extra special to me because Ezra sent them.

The gasoline shortage didn't hurt us at all. Our old work horses ran on willpower. We

never had money for a car, so the automobile
and tire rationing wasn't a problem. Ezra
owned a Model A in which (when he was home)
he took us places.

Our faith considered tobacco to be a sin be-
cause it was such a filthy habit, so this ra-
tioned product wasn't a worry for us. I doubt
that it caused a great problem with other
people either, because many of them grew their
own.

DREAMS AND WISHES

Lost in her embarrassment,
She watched as they strolled by
Dressed up in their finery
While she just sat and cried.

She twitched her nose
And smelled the rose
From scent of their perfume;
It must be great to smell so nice,
This thought she just assumed.

Her clothes were worn and tattered,
Her shoes worn through the sole,
Cardboard placed inside the shoe
To cover up the hole.

Her embarrassed thoughts
Then turned to dreams
Of all her wishful needs;
She dreamed of her Prince Charming
Astride his mighty steed.

He'd come and take her far away
And make her dreams unfold;
He'd teach her love would be a prize
More valuable than gold.

— By Wilma Groves Harryman

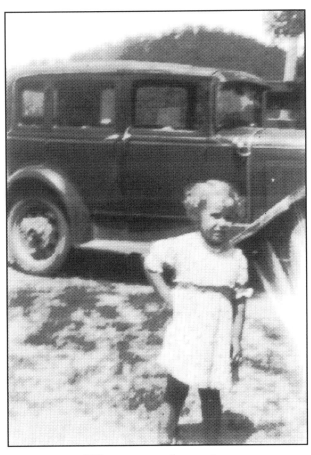

Wilma, at age 5, wearing
one of her flour sack dresses

Chapter 19

PO' FOLKS RECYCLING

With the money Daddy received from the sale of the molasses and tomatoes, working for WPA, cutting cedar posts and any other honest work he could find to earn an extra dollar, Mom went to the nearest General Store. The money ran out quickly because this shopping spree didn't come about very often. Mom's purchases included the bare necessities such as: flour, cornmeal, salt, baking powder, baking soda, lard and pinto beans, to name a few. When money allowed, she got sugar and thread. Then there was the lye to make our soap.

Any container that came with something in it was washed and used for a variety of different things.

The lard came in a five-gallon metal container known as a stand. After the stands were emptied, they were used for storage containers.

Several foods were stored in them such as: dried beans, flour, corn meal, and so forth. When my dad ran out of gallon syrup buckets, he used the lard stands to store molasses. The stands also came in handy as an extra seating place. Some of the country ladies cushioned the top and covered them with pretty fabric. They were then used for decorative chairs and foot-stools.

In those days, recycling wasn't an ordinance, it was a necessity. Very few food containers were thrown in the trash.

Our glass fruit jars were used again and again. When they were emptied, they were washed and put away. Always before the next canning, they had to be washed again. I remember well, because I was often chosen for this position. Not that I was better at it than anyone else, but I was the only one with hands small enough to get inside the jars.

I remember Mom collecting soda pop bottles to make drinking glasses. I'm puzzled as to where she got the bottles because we did not buy soda. That would have been considered a luxury. Anyway, she got them (probably from the local trash dump site), and I remember watching her making the glasses.

This project was quite tedious. Her basic tools were the bottles, paraffin wax and heavy string or twine.

The wax was put into a pan and placed on the hot wood stove. While the wax was melting, Mom used a pencil to mark the place where the bottle would be separated. She then dipped the string into the hot wax and carefully placed the string around the marked bottle. A match was struck and touched to the string to ignite it. This procedure was continued until the bottle was in two pieces.

Kerosene could be used instead of the hot wax, but if the substitution was made, complete caution was necessary.

After the bottle was separated, Mom used fine sandpaper to smooth the top of the new drinking glass.

To complete a set of these glasses was very time-consuming, but finished they would be. Mom loved creating things, so she truly enjoyed this. This being the case, her patience was endless.

Our flour and cornmeal came in cloth bags, which were of a pretty print. The food for the

animals also came in cloth bags. Some of these were printed, but many of them were an off-white, somewhat drab shade. The plain bags were taken apart and sewn together for sheets and pillow cases. Others were hemmed and used for dish cloths and dish towels. The pretty prints were made into blouses for us to wear. Dresses were made from them as well. (when enough of one print was collected). I'm sure my brothers wore their share of flour sack shirts, although the smallest person in the family wore more than their share of the recycled bags. In this case it was I who lucked out. You see, this fabric was used for the larger part of my wardrobe.

I know I should have been thankful for what I had. I'm sure there were children who had less than I did, but since I was only a child, I'm afraid my gracious ways were far in the future, i.e., Mom had just finished making me a dress out of flour sacks when a knock sounded at the door. Mom went to the door, and it was a neighbor lady whose name was Gertie Benton. Mrs. Benton and my mother visited while I sat and listened to their conversation. One subject led to another, and when sewing was touched upon, Mom picked up her latest creation. She said, "Gertie, I managed to put this together out of two fifty-pound flour sacks." Mrs. Ben-

ton said, "Oh, how pretty!" Then she asked, "Is it for Wilma?" I then spoke up and answered the question which was directed at my mother, "Yes, it's mine, all I ever get is flour sack dresses." That's me, always talking when I should have been listening.

Mrs. Benton obviously felt sorry for the little sack-clad girl because she came back a few days later with enough seersucker fabric for two dresses, "For me."

Mom designed and sewed the dresses. One dress was a soft pastel pink, and the other was a pale turquoise. I remember how soft they felt and looked. I truly loved those dresses, and I wore them, knowing they were true gifts of love from two very dear ladies. And they weren't made from flour sacks.

I have since felt guilty for complaining because my mother was doing the very best that she could, but children will be children.

Chapter 20

A RING FOR WILMA

I was always in awe of females who dressed well or wore pretty jewelry. I yearned for such things, so I decided to help things along. In my mind I designed myself a ring. I collected the things I needed: a piece of copper wire, a kernel of colored corn and a hammer to bend the wire to my specifications. I raised the hammer up and brought it down and oops! It missed its target and found my thumb. Oh, the pain! I must have yelped like an injured puppy because Mom came running in answer to the painful cry of her offspring.

After my thumb was bandaged, Mom, who I'm sure was feeling sorry for me, fashioned the prettiest Indian ring. When she gave it to me, she said, "Wilma, I hope this will help to make up for you mashing your thumb." It was truly amazing how much it helped the pain.

To make my ring, Mom wove small Indian

beads with tiny copper wire. What a beauty! I wore it with genuine pride. Thinking back, I now realize more than pity went into that ring; love was woven in as well. Needless to say, I completely forgot about the one I was making.

The baby of the family usually has more advantages than the older siblings, and I was no exception. The most important of the advantages was being able to spend more time with my parents.

Mom used some of our quality time to make things for me. She never threw anything away, so when she had the time to create, she had no trouble finding something with which to work.

I loved the little jewelry boxes she made for me. She used the large match boxes (approximately 5" x 2") to glue or paste together — two boxes high and three across. She removed the sliding container of the box, to be left out until the unfinished jewelry chest was covered with scrap wallpaper and allowed to dry. The sliding insert of the box was left uncovered, and tab buttons were sewn onto the ends of them. The buttons made cute drawer handles. When the wallpaper was dry, the box inserts were slid into place, and my treasure was finished. My jewelry supply was limited, but I

loved my jewelry box anyway.

Old shoe boxes were turned into toy wagons. Mom's emptied wooden spools were the wheels, and a braided twine or yarn served as the wagon tongue.

More treasured memories are the songs Mom taught me. The one below is sort of a tongue twister, to be sung as fast as possible.

I SAW ESAU

I saw Esau sittin' on a seesaw,
I saw Esau with a girl,
I saw Esau sittin' on a seesaw,
He was givin' her a whirl.
When I saw Esau, he saw me,
Then I saw red and got so sore,
Then I got a saw, and I sawed Esau
Off that old seesaw.

This is just one of many songs that Mom taught me, but this is a favorite with my grandchildren. In my opinion, a very good reason for choosing it.

Chapter 21

FOLKLORE

It's a well known fact that the Ozark people have many unique theories about life. My mother collected these theories like wild flowers.

An instant example is a method for predicting a child's destiny or vocation in life. This procedure required nothing more than a Bible, a dollar bill, the child and the parent. As I remember, the child needed to be at least one year old. He or she was seated on the floor or on the bed. The Bible and the money was placed in front of the child. If the child reached for the Bible first, he or she would work for God. If the money was chosen, chances are the child would work for financial gain and live more dangerously. I do not know why Mom used this method only on my brother Dan, but such is the case. This is rather strange, but of this theory a believer she became, because Dan chose the Bible, and when he grew up he didn't

disappoint her. And he was the only one of their offspring to be in the ministry. He was a respected Minister of evangelism. A member of the Assembly of God Faith, he was a wonderful messenger of God.

My parents would have been in "Hog's Heaven" if more of their children would have been Ministers of the gospel. But it just wasn't to be.

A preacher story in a different light is about my brother Ezra. This is another of Mom's well loved stories ... my four oldest brothers, Asa, Dan, Ezra and Perry were playing church. The yard was their meetin' house, and a wooden crate served as the pulpit. Standing on the crate was Ezra, delivering his sermon to his brothers. He was saying, "Apostle Paul and so was Peter," when suddenly he jumped off the box and exuberantly stated, "There goes a June bug — gosh, ain't he a biggun." His short sermon and ministry were concluded with the chase of the June bug.

Children's games often consist of subjects of the actions they most often witness. Consequently, one of our most common games was church.

Occasionally we also held a funeral, since funerals were well attended in those days.

I shall never forget the day we buried my favorite doll. Missie was laid to rest for several days before I decided it was time to deliver her from the depths of the earth ... and too I wanted to play with her. Woe was me and the poor little doll because I forgot where we buried her, and I never found her. I can't remember for sure, but she was probably the only doll that I owned. I didn't have many toys, but I had love, although I don't recall my parents being overly affectionate. And that might have been a blessing. Sometimes parents can overdo it and be too gushy.

My parents showed their love in many ways, and I had no doubts about the way they felt about me.

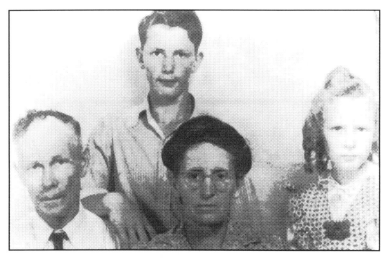

My mom and dad, my brother Bill and me
January 1946

Chapter 22

GETTING ON WITH OUR LIVES

Dad not only preached in and around the Branson/Blue Eye area, but traveled to other Missouri towns as well. These trips were due to revivals he would be holding, and I'm happy to say, "We didn't have to move out of our area."

On these trips Naomi and Avenell often traveled with Dad. They sang and played the guitar and mandolin for the services. Usually Mom needed to stay home and take care of the garden or whatever, so, of course, this left Bill and me behind as well.

The traveling that was done in our family required us to catch a ride to Springfield, Missouri, and from there take the Greyhound to our destination.

Two of the trips of which I spoke are the reasons Naomi and Avie married men who resided away from our area. In Lathrop, Missouri,

where my father held a revival, Naomi met Lester Norris. A few months later they were married. This particular vicinity was where they made their home and raised their family.

Another revival-necessitated trip was to Saint James, Missouri. This is where Avenell met Carl Roark, and soon after they were married. They too remained in the same area, made their home and raised their family.

My brother Bill was fourteen when he began working away from home. He lived with the people for whom he worked, went to school and worked weekends and evenings.

Of the entire brood, this left only me. I was very lonely and often wished for sisters to play with. I think my loneliness inspired Mom to do more things with me. I've learned from conversing with some of the family that when the older siblings were growing up, Mom was so busy that she had no time left for any sort of recreation. Due to this fact, I was lucky to be the youngest child, but in another way it was unlucky for me. If I had been one of the older siblings, I could have enjoyed more years with my parents. With this, as with many things, the pros and cons existed.

I don't recall exactly how long we lived in the log cabin. I know we moved more than the average family.

At one time Mom counted the amount of times we moved in one year, and the total was twelve. We moved so often because my father didn't drive, and he went where the Lord called him to preach. So we resided as close as we could get to the church where he would be preaching. This was the logic behind our vagabond existence. It was a rather uncomfortable way to live, but Dad lived what he believed, so I won't fault him for his ways. Anyway, I loved him too much to question his motives.

I think we lived in the log cabin longer than any other place, although of this queried statement I'm not positive.

Each time we moved, Mom went to work to put the badly kept place in order. She scrubbed everything. I remember watching her exterminate for cockroaches. She sprayed the cabinets liberally with the insecticide DDT. She gave the DDT a proper amount of time to do a decent job on these filthy insects and then washed the cabinets with hot, soapy water. She then poured pots full of scalding water in the cabinets to sterilize and rid them of all the insecticide.

In most of our dwellings, Mom papered the walls with newspapers. She would say, "They're not pretty, but they're clean."

To this day, I continue to live in awe of the many, many tasks my mother performed for our basic survival.

Chapter 23

THE REVIVAL

In March of 1946, my father, mother and I were living in an old hotel. Dad had rented two rooms in this hotel, which was located in the little old English town of Hollister, where the main street is named Downey Street. Hollister is just two miles south of Branson.

Daddy became very ill while we were living in the hotel. Even with bad health, he said he felt he had been called to hold a revival in Holt, Missouri (a small town several miles away). In our faith, when one is called to do something, this means the person believes that God has spoken to them and asked them to do a special service.

He really wanted to answer God's call, but he was just too ill. He prayed endlessly for his health to improve, but it seemed to stay the same. He was so sick that we feared he was dying. Two Ministers who were acquaintances

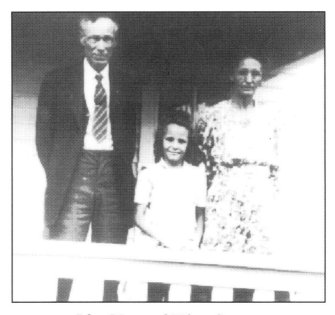

John, Mary and Wilma Groves.
This photograph was taken during the
Holt, Missouri revival — Spring 1946.

of Dad's heard of his illness and came to our rooms to pray with Mom and Dad. The Ministers anointed him with oil, and they prayed their humble prayer for his healing. I was saying my silent prayer, because I was very, very worried about him. When they had finished praying, Daddy was immensely improved. He said, "Thank you, Brothers, I believe with God's help we got victory over this."

His health improved so much he was able to travel to the out-of-town revival.

For this trip the only traveling companions Daddy had left were Mom and me, so we went with him to Holt.

It is truly strange how some things happen — Dad was given a reprieve from his health problem for a reason. I don't remember much about the revival. If I could, perhaps I would understand why my father was given the chance to fulfill his religious calling about which he felt so strongly.

Just short of the revival ending, Daddy's health took a turn for the worse. By the time we got back to Hollister, he was very ill. To make matters worse, when we arrived at the hotel, we found our belongings had been taken

out of our rooms and placed in the hall.

The man we rented from was a long-time ac-
quaintance of ours. I do not know why we were
evicted (so to speak). I can only assume that
our rent was due and the owner found another
renter. Oh well, business is business, I guess.

On behalf of the hotel owner, I will say he
was kind enough to allow us to use "one" of his
rooms until we could find another place in
which to live.

My tenth birthday rolled around at this time
(one of the few, as a child, that I remember).
As broke as my parents were, they gave me a
little cedar-bound autograph book and a hair
ribbon. I still treasure and hold in my posses-
sion the autograph book. It's filled with special
words from some of my favorite people.

Chapter 24

OUR "FOWLEST" HOME

The date was April 1946; we were back in Hollister, Missouri. My father was very ill, and we were as good as homeless. Our funds were very low, and we were desperate to find a place to live.

To save the day, my mom's pioneer spirit kicked in, and with the meager means at hand she went in search of shelter for her family.

If you will take into consideration our shortage of money, a limited amount of time to find a place and a transportation problem, I think you'll realize why Mom rented the place that she did.

Our new home was only a few miles from Hollister, and the rent was only four dollars a month.

The inside dimensions were approximately twelve by twenty feet. This was definitely our

"fowlest" home yet. The previous tenants didn't worry about using an outdoor toilet. You see, they were honest-to-goodness turkeys.

My brother Asa's two oldest sons helped me and Mom to clean it. We shoveled and raked and shoveled and swept until we were all nauseous. The odor and the heat combined sent our senses reeling with a violent form of disgust. I'm sure Roger and David saw turkey defecation in their sleep after our clean-up experience. I know I did.

When we had cleaned to the best of our abilities, Asa and Perry moved us in to our new abode.

After our meager belongings were put into place, Mom took a look around and humorously stated, "This place ain't big enough to scold a cat without gettin' hair in your teeth." Mom had a way of sugar coating our bad situations with humorous statements.

Now to describe our new living quarters. I honestly don't think you'll get bored, it won't take very long.

In the one and only room of our home, our mirrored dresser and the old wood-burning

cook stove were placed "back to back" in the center of the room. This arrangement provided a partition of sorts. The back section of the turkey shack was our bedroom, where two small beds were placed. Dad slept in one, and Mom and I slept in the other. The front section was our living room, kitchen and whatever.

When you're so poverty ridden that you have to save up to be poor, it's necessary to stop and consider the things for which you can be grateful. In this case it was the dirt floors. Granted, they weren't very elegant, but we didn't have to sweep them. Occasionally they needed to be raked, but you cannot successfully sweep dirt floors.

Now this was a dwelling to write home about. This place made our log cabin look like a mansion. Yet another lesson in appreciation.

We moved into the small building toward the middle of April. At that time, the heat was bearable, but as the days moved on into May and June, the indoors of our home was excessively hot. We must have been as tough as boot leather to survive such living conditions. This poor excuse for a home certainly wasn't acceptable for a person in Daddy's state of health.

Chapter 25

FAITH

Daddy's illness had grown progressively worse while we were moving. Now he was bedfast most all the time.

These were very sad times, but there was a measure of happiness mingled with the sadness. I loved being with my father, and this situation had allowed me to spend more time with him; yet I was aware of the fact that my time with him was limited. Acknowledging this made our days together even more precious.

By this time we were into June, and the days were beginning to heat up; that little shack was even hotter than the log cabin. The days slowly dragged by for Daddy, who had always been accustomed to staying active.

I entertained him as best I could; I sang the old "Cindy Went a Preachin'" song, but I re-arranged it a bit:

Daddy went a preachin';
He shouted and he squealed;
He got so full of glory
He tore his stockin' heel;
So get along home, Daddy, Daddy,
Get along home,
Get along home, Daddy, Daddy,
So Mom can sew your heel.

He teasingly scolded me while I giggled.

On the days when he felt a little stronger, we took a quilt out in the yard and laid it under a shade tree. I sat on the quilt with him, and we played a game, using the Bible as our game book. At random, I would select the numbers of a chapter and verse of a certain book. It didn't matter where I opened the Bible, Dad was able to quote the correct scripture. I would then choose a chapter and verse and read it to him, and without hesitation he would tell me the numbers of the book, chapter and verse. It was impossible to stump him. I still think about how amazing he was in his knowledge of the Bible, especially considering the fact that he didn't learn to read until he became a Christian.

As the days passed, Daddy's health contin-ued to fail. It gradually got so bad that even

the Bible game was impossible.

Because of his faith healing, he held stead-fast in his refusal to see a doctor. He said, "If God wants me to live, He'll heal me, but if it's my time to die, then I'll go."

His illness then kept him in bed all the time, and I knew he was in pain, but he never fal-tered from his belief. Nevertheless, as strong as his faith was, his health just would not im-prove. He became so frail, I remember my mom saying, "I don't think he will weigh even a hun-dred pounds." Tiny little Mom bathed, lifted and turned him over in his bed, until Bill came home a few days before he died. Personally I didn't assist in the bathing and turning him, but I helped by fanning him and by giving him water and Pepsi to drink. The latter seemed to soothe his tortured stomach.

With hopeless sadness, Bill, my mom and I took care of him to the end.

Our faith healing belief established the fact that Dad's only doctor was God. Consequently, we never knew for sure the true nature of Daddy's illness. Mom formed a conclusive prog-nosis, which was prostate cancer, but I will al-ways wonder exactly what the diagnosis would

have been if a qualified doctor had examined him.

When he knew for sure he was dying, we were all gathered around him, and he gave me his newest Bible which was a little pocket size. He said, "Wilma, I want you to have this, and I hope that you will be a preacher." I still have the Bible, but I'm afraid I haven't fulfilled that particular wish.

Only a few moments before he died, he asked us if we heard the music in the yard. He said, "The angels are singing, and it's such pretty music." And then he died.

To this day I have vivid memories of the night my daddy left us. Lord, how I hated to lose him, and even after all these years I still miss him. Over the years I've had several dreams that he came back to life. So realistic were the dreams that I would awaken with an awful sadness. He died on June 28, 1946, just two months and eighteen days after my tenth birthday.

I will always respect my father for being completely faithful to his beliefs, but I've always felt that I was cheated out of many good years with him because he believed so strictly.

Dad's funeral was held outside, in the Bowman Church yard. The people who planned the funeral anticipated a large gathering, and they were right. An incredible number of people came to show their last respects. A wonderful testimony to Brother John Groves.

DADDY

In the autumn of his life
I watched him fade away,
My heart in puzzle pieces torn,
And then I heard him say:

"Don't fret, my darling baby girl,
Death is but a song;
I'm going where the angels sing,
Where there will be no wrong.

I'll rest and read my Bible;
I'll walk on streets of gold;
I'll shake the angel's hand of love,
My restful peace unfold.

So, darling, I'm not leaving you;
I'll be there in your heart
To keep you safe and comfort you,
From fear keep you apart."

— By Wilma Groves Harryman

A CROWN OF FEATHERS

Another bit of folklore concerns a pillow. Yes, you read it correctly, a feather pillow.

The Ozark belief is as follows: if a person has been lying on a feather pillow at the time of their death and the pillow has not been disturbed in any way for at least two weeks, then when the pillow is opened and a crown of feathers is found inside the pillow, this is a sure sign that the deceased has gone on to Heaven.

I don't remember how many days we lived in "gobblers mansion" after my father passed on, but I know it wasn't quite two weeks. I know this because Mom was curious about the feather pillow adage and didn't want to disturb Daddy's pillow. But we had no choice in the matter; we desperately needed to move. Anyway, we knew Dad was in Heaven. No more suffering would he know, no more sadness, no more sorrow and no more worries about making ends meet. It was such a comfort to our hearts to know these things.

Crown of Feathers

Chapter 26

A STEP UP
July 1946

I must back-track a bit and tell you why we were able to move so quickly after my father's death.

Two of my brothers, Asa and Perry, were building a two-room house for us. They began work on the house when we moved into the turkey shack. We actually moved into the house while they were still working on it. Our new home was several miles from Branson and Hollister. It was really only around fifteen miles, which is several when you don't have a car and you couldn't drive it if you had one.

From where our little house stood, we could see both homes of Asa and Chloe and Perry and June. Living so close to them gave us a feeling of safety and security.

This housing location was an advantage for

me because my nieces and nephews lived close. So we spent many hours playing together.

Sometimes when we were close by, we would wander into Perry's and June's pottery shop and watch them work. They made beautiful pottery, such as bird baths and several sizes of flower pots. They not only sold these items locally, but they also shipped them. They would load their pickup truck with the pretty wares and haul them for miles and deposit them in pottery shops to be sold on consignment. They also sold their goods locally.

Our new home was small but much appreciated, especially after living in the turkey shack. At least it was cozy and clean.

My brothers finished the exterior of the house, but the interior was, for the most part, left for my mother to do. And this she did. She took her job seriously of making our little house as comfortable as possible.

Her first job was to lay the board floor. She used a hand saw to cut the boards to the correct lengths before nailing them in place. When the floor was laid, she covered it with cheap linoleum.

Mom planed and varnished cedar lumber to be used as facings for the windows and doors of the interior. After the varnish was dry, she then nailed the facings in place. Mom was a motivated woman and not a bad carpenter either.

The floor was laid, the facings were in place; then the next step was to make the walls presentable.

To begin her next home improvement task, Mom took herself, her resourcefulness and her determination to Branson, where she spent hours going through the wallpaper remnants at Whelchel's Hardware Store. She patiently sorted and searched for enough matching paper to cover the walls of the two rooms.

Whelchels charged her ten cents a roll for the wallpaper. Remember, this was 1946. A shoestring living was more possible then than now.

Mom carted her purchase home, made a paste out of flour and water and hung the floral-patterned paper.

An ordinary house has sheet rock for the walls, but ours was lacking this luxury. So

Mom put the paper up without benefit of smoothness. The two-by-four studs were visible, so she hung the paper from the top down to the middle horizontal stud and covered the stud with the paper, then brought the paper on down to the floor. The covered studs then served as shallow shelves to use for trinkets or whatever.

When the walls were all covered, we were amazed at the difference the paper made in our small, humble quarters. The pretty print added much warmth and cheer, and the rooms actually appeared larger.

When Mom decided to paint the ceilings, she asked Perry and June's son Richard to help her. Richard was the oldest and tallest of the kids; I assume this is why she asked him to help. On the other hand, maybe he was a good painter. They had been painting for awhile, and Richard was beginning to get antsy. He looked at Mom and said, "Grandma, my neck's a breakin'." Mom's quick reply was, "Don't worry, son, if it breaks, it's long enough to tie back."

If my mother could have lived in this age, she could easily be a stand-up comic. She was witty and humorous, even at her most exhausted moments.

I have often thought that hill people use their sense of humor to alleviate stress and worry.

Electricity was still not in our budget, so we continued to use the old kerosene lamps for lighting purposes. I have always loved those lamps. They cast the softest glow in a room and add so much ambiance. I must tell you, though, the moments can become rather anxious when the wick burns down too far. When this happened, the flame would burn too long before the wick was turned up and the fire would follow the wick down into the bowl of the lamp. I saw this happen once. Mom wielded that skinny wrist of hers and threw the whole lamp out the door. I was happy to see the lamp explode in the yard instead of the house. I stood there with my mouth open, in awe of my mother's quick thinking.

One lived for this sort of unusual happening. It was probably the most exciting thing to happen in Lord knows how long.

We finally got our house wired for electricity in 1950. Then the lamps were only used as decorations, unless we suffered a power failure; then they were re-lit. A welcoming and handy

item they were to have, too.

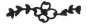

INTERIOR DESIGN
AT A BARGAIN

Our living room was also our bedroom. In one corner of the room we placed the double bed and in the opposite corner the old mirrored dresser.

Somewhere and somehow, Mom managed to find a neat little wicker sofa set. Of course, it was a bargain, or she couldn't have bought it. I'll never forget how proud I was of that set. It was placed in the end of the living room, opposite the bedroom area. To me, the wicker set seemed to make our room very cozy and inviting.

To add to the warmth of the area, Mom sat the King Heater in front of the sofa and chair, put the stove pipe together and ran the pipe up through the flue. The cheap heater was then ready to fire up. How cheap was this heater? It was so cheap, when it held a hot fire, the sides of the stove became a bright red. It was constructed of a metal (tin, I think). The purchase price of a King Heater was only a few dollars, and their cheap construction could endure only one winter. So when summer came,

the heater was thrown away, and come the next winter another one was purchased.

Between the heater and the kerosene lamps, I am completely in wonder and amazement as to how our little house kept from burning to the ground.

When the main room of our humble abode was decorated with the furniture and wallpaper, Mom took a look at the windows and said, "I guess I had better make some curtains; we don't want any uninvited on-lookers."

She opened her old treadle sewing machine and searched through some boxes for enough matching flour sacks to make the window dressings. With no surprise to me, the curtains were quite pretty. Unique, but they were neat.

With the living room/bedroom finished, Mom's next project was to decorate the kitchen.

I knew that with Mom's ingenuity, patience, energy and talents, our kitchen would be as pleasant as our main room.

I'm sure it was a good feeling for her to do so much with so little.

Mom also laid cheap linoleum in the kitchen.

The walls were papered with the same method as she used in the living room (covering the two-by-four studs). Going back to her bargain wallpaper stash, she sorted out the ones with a kitchen pattern. They were not all of the same pattern, but she managed to hang the paper in such a way so that it was somewhat coordinated.

For the two windows in this small room, Mom dug out some more flour sacks and dressed the windows in country fashion.

On the other side of the wall, opposite the heating stove, the wood-burning cookstove was placed. This particular placement position was necessary because the pipes from both stoves needed to be inserted into the same flue.

An old-fashioned cabinet stood against one wall — the kind with glass doors, a flour bin and a dough board. Our small table and chairs sat in the middle of the room. I assume the reason our closet was in the kitchen was because it was better hidden there than it would have been in the front room. Since we didn't have a bedroom, it had to go some place.

We had also acquired an old icebox, which was without ice most of the time. Occasionally an ice delivery truck would come through our

area. If we had the money to spare for the fifty-pound block, our icebox would be cold for a while. Quite often though, we couldn't afford the meager amount, and this was just another instance when we were thankful for the spring. It still served as an outdoor icebox.

Remember the mustard yellow table that served as Dad's pulpit? It was placed in front of one of the windows for the enamel wash pan to rest upon. Yes, it was still mustard yellow.

As was par for the course, we still had no indoor plumbing at our new place. But Mom was very fortunate in finding a spring unusually close to the house. This continued to be our main source of water, although we still placed barrels under the eaves of the house to catch the rain. As for the spring water — we were luckier than we realized, because the water was pure and clean, and it was free. Today many people buy spring water at the grocery store and carry it home in bottles.

Asa and Perry built us a new outhouse or "privy" as Mom enjoyed referring to it. But our new two-holer was better, because we had reading material on the walls. In this small building there were cracks between the boards,

so Mom used a thick layer of old newspapers to cover the walls. This ingenious procedure prevented the cold wind from whistling through the cracks in the winter time.

When summer rolled around, our dated news disappeared. You see, we needed the cracks for ventilation. But when winter came again, we got a new wall of dated news.

Oh yes, we still had the catalog to use for toilet paper and with which to dream.

I'd walk in to that ever-so-cold john, make my nest, open the Sears and Roebuck catalog and move right into one of those warm, pretty rooms. My dress was red velvet, with shoes to match. My pearls were the real thing, and my wrap was black velvet. In my daydream I was ready for a grand party. I opened the door, but instead of stepping out onto a cobblestone walk, headed toward a sleek black Buick, I was tiptoeing on a rocky path to our little house. When I entered the room, instead of sparkling chandeliers and velvet furniture, I saw the kerosene lamps flickering on the wicker sofa set. The marble floor was cheap linoleum, and the only other party member there was my mother. She wasn't much of a party girl, but she was a precious lady.

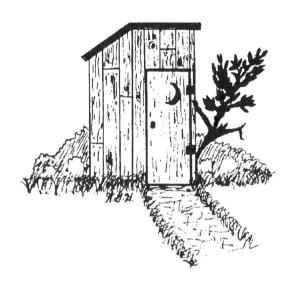

MOON OVER THE OZARKS

Out back behind the log house
There sat a one-room shanty
With holes carved in the sofa seat
To accommodate the fanny.

A moon was carved upon the door,
I guess for ventilation,
Or maybe it was put there on
For simple decoration.

We always kept a book inside
For wishes and our dreams;
Another purpose yet it served,
To keep our bottoms clean.

In summer when the mercury climbed,
The heat was hard to take,
But winter brought a different pain
That caused our cheeks to ache.

This building was a wee bit crude,
Its pleasantries denied,
Our only other option was
To grin and bare outside.

A reason for discomfort is
To cultivate the soul,
To show appreciation,
Thus help our minds to grow.

But still we often squawked and griped
For yet a better space
To carry out our natural needs
With comfort's healing grace.

So each and every time you flush,
Stop short and think of winters
When folks of many years ago
Would sit upon the splinters.

— By Wilma Groves Harryman

When we moved into our new dwelling, Mom was fifty-four years old. This wasn't an ideal age for a woman to find employment, especially if she had no form of consistent transportation. Also, at that time, employment was limited.

To subsidize our means of living, Mom took in sewing. Quite often the people she sewed for couldn't afford to pay very much, so she altered the price of her services to fit their pocketbook.

At this rate, we simply could not make ends meet. Mom would say, "Money is as scarce as hen's teeth."

The financial pinch from which we were suffering was not a new thing for us. But it was different then because we no longer had Daddy to depend on. Mom decided we had to do something in order to survive, so she applied for welfare, and without surprise we qualified. Once a month we received a check from the humble pie place for twenty-seven dollars. That's an average of eighty-seven cents a day.

How in the world we ever lived on such a small amount, I will never know. If Mom had not been the wonderful manager that she was,

we couldn't have gotten by. Well, at least we had a pot to pee in and a window to pour it out of. But Lord knows, we didn't have much more. In her jovial manner, Mom would say, "We'll get by, by the skin of our teeth," and somehow we did.

Chapter 27

AN ERA IN THE LIFE OF A STITCH

Rummage sales served as one of our life preservers, and Mom visited these as often as possible. Her favorite rummage sale was held at the Presbyterian Church in Hollister, Missouri. After we moved to the two-room house, we were not in walking distance of Hollister, but Mom usually managed to get to the sales, one way or another. She often rode to town with Asa or Perry. Sometimes she thumbed it, and sometimes she rode the school bus and instantly became another kid. She was forever the entertainer.

The church sales were only held once a month; consequently there was always a long line waiting for the door to open at nine a.m. on these special days.

The sale was promoted by the church to subsidize the church funds. The items that were purchased by underprivileged people were

much needed and appreciated.

In one area of the sale, large boxes of assorted things were sold. The boxes varied in price, depending on the value of the contents, and they were bought, contents sight unseen. Mom usually bought the one-dollar boxes.

Even though she bought the cheapest boxes that were sold, we always had a lot of fun sorting through them. Sometimes there were small household items, but usually there were more clothes than anything. Mom would say, "I can make a blouse out of this and a skirt out of that or maybe even a dress."

Most all of the items in the boxes were utilized in one way or another.

In one of the families that went to our church there were several children. More than the parents could provide for properly.

Mom put her trusty treadle into action and fashioned and created a variety of little garments for these children. Sometimes she used clothing from the rummage sale boxes for her fabric.

Quite often, the people for whom she sewed

were short of money, and Mom would charge them only a dollar for everything that she had made. She truly believed that a good deed came back doubled. Now I know this was wrong and sinful of me, but I recall thinking, "Good heavens, we ought to be rich by now!"

I always considered myself very lucky that my mother was so talented. If this had not been the case, I would have dressed much more poorly than I did.

Another example of her talents is in reference to a pair of sandals. I'm guessing my age at the time of the sandal incident. I think I was about twelve or thirteen when Mom ordered me those shoes. They were white, and I was so pleased to get them. I was always so proud of anything new (especially things to wear) that we got, but the sandals didn't stay together very long.

In those days, if a good price wasn't paid for ladies shoes, the serviceability of the footwear was very limited. To my chagrin, my white sandals followed the path of the aforementioned fact. My mother, not to be outdone, looked the shoes over very carefully and came up with an idea so they wouldn't be a total loss.

Since the sole outlasted the upper part of the sandal, Mom took the shoes apart. She then went into her rehabilitative mode and began the overhaul job on the shoes. She used the upper pieces for a pattern. This part of the shoe was cut from the upper section of an old pair of boots which were in one of those rummage sale boxes.

The "lady cobbler's" next step was to paint the leather red. When the paint had sufficiently dried, she glued the painted pieces back into the places which the soles had previously provided. She then attached the buckles from the old shoes to the new ones, and I was the proud owner of a new pair of red sandals. I loved those shoes: reason one, because they were red, and two, because I knew they were done with a labor of love.

Those reasons should have been enough to make me happy, and they were until ... I wore the shoes to school and was quite proud of them, and then one of the girls from an upper grade made wisecracks about my homemade shoes. That was the last time I wore them. My pride (which Mom referred to as "false pride") didn't coincide with our means of living.

With a few years on me and a few experi-

ences behind me, I now see how foolish I was to feel the way I did. I sincerely hope I didn't hurt my dear mother's feelings, but I probably did and now it's too late to apologize.

I've heard it said that hindsight is better than no sight, but if I could do it over, I would make every effort to avoid hurting my parents' feelings.

MY NEW COAT

We didn't have to wear coats of many colors because Mom turned old coats for us which were purchased at the rummage sales. For this job, she basically used the same procedure as she used with the shirt collars, although with the coats there were many more stitches to be removed. Mom took all the seams apart, turned the fabric over, sewed all the pieces back together, and behold, a new coat. The difference between the old coat and the turned coat was the buttons were on the wrong side, and quite often the fabric was a shade different in color.

When I was twelve, I don't know how, but Mom got me a new coat. My first new coat — I will never forget it. It was a teal blue, and I was so proud of it. But I was soon beginning to believe that I was destined to wear coats

with the buttons on the wrong side. Mom and I were in Branson to buy a few things that we desperately needed. One of the items was a tube of glue for small household repair jobs. I was playing with the glue and accidentally squirted it on the front of my coat. To me this was a bad accident, because in my heart I knew what this meant, another turned coat.

At first, Mom was somewhat, or maybe I should say completely, put out with me. I can't say that I blame her. But with mothers, time heals all messes, so in a short while she was trying to comfort me. She said, "If I can't get the glue out, I can turn it." I will say, this did help, but I was still hurt. She went on to say, "Let's go get that ice cream cone." It's amazing how medicinal ice cream can be to a child, especially one who seldom has this delicate treat.

We didn't go to Branson very often, so I really looked forward to those trips. The highlight of the day was the ice cream cone. For several years Alexander's Drug Store sold a double scoop cone for a nickel.

I saved mills for the ice cream purchase. The cone took fifty mills. A mill was a small coin worth one-tenth of a penny. I'm not sure exactly when the usage of these discontinued. I

think it was sometime in the late forties. The coat incident happened in 1948, I think, so I believe my guess is fairly close. The mills were issued for tax purposes, and Mom let me save them until I had enough for my sweet tooth fix. When I finally collected the fiftieth mill, I was ready to go to Branson and buy my double scoop.

Mom's promise to fix the coat, along with the ice cream, soothed my ruffled feathers. But I never quite forgave myself for ruining the fashionably correct side of my pretty teal blue coat.

A RECIPE FOR HOPE

Take a cup full of love
And blend it with faith;
Stir in some strength
For humility's sake.

Add a pint full or two
Of unflagging endurance;
Sift in some goals
And mix with assurance.

This recipe is filled
With nutrition and soul,
And it offers the strength
To achieve desired goals.

Bake in a warmed heart *The quantity of yield*
With patient precision *Will be your decision*

From the kitchen of:
Wilma Groves Harryman

Chapter 28

MY GRADUATION DRESS

In the spring of 1950, my eighth-grade graduation was approaching, and I didn't have an appropriate dress to wear. This fact did not put a smile on my face. I'm sure I did more than frown, so once again Mom came to my rescue. She told me to fetch the catalog, find the dress that I wanted, and she would make it for me.

This time the catalog was more than a dream book for me, it was the book that helped to make my day.

My dear mother took some of our meager funds and bought pastel yellow taffeta. She took my measurements and cut the pattern from a newspaper. When she was finished, the dress looked identical to the one in the catalog. It was absolutely incredible and, without a doubt, the prettiest dress at the graduation ceremonies. At least to me it was.

It was close to this time period when the
peek-a-boo skirts came in style for young girls.
Again Mom copied from the catalog and made
one for me.

At the bottom of the skirt, in the front on
the left side, a piece of the hem was gathered
up into an inverted V. Under the hem was
sewn strips of white lace. This little addition
was meant to resemble a slip or under-skirt.
When I wore the skirt, I sincerely hope that I
looked as cute as I thought I did, although I
rather doubt it.

I get a very warm feeling for my mother
when I remember the things she did to please
me.

A MOTHER'S LOVE

She worked from sun to setting sun;
She used a walking steady run;
Respect for her was reverent;
Her walk was tall where e'er she went.
From old used grease she made our soap;
She carried water from the slope;
She sewed our clothes from flour sacks colored,
And when we hurt, the pain she mothered.
My mother's homes were never great;
She toiled and strived to fill our plates,
Cooking, canning and ever trying
To keep us fed when snow was flying,
But now she has a new home
Where she and all the angels roam;
New stitches they have learned from her
To sew their robes of gossamer.

Composed and written for my mother
Mary Amos Groves

— By Wilma Groves Harryman

MY FIRST MOVIE

In 1950, at the age of fourteen, I was beginning to crave some excitement in my life. So when Perry and June invited me to go to the newly completed drive-in theater, I was excited but also fearful that I wouldn't be allowed to go. Mom wasn't gung-ho about me going because our church didn't approve of movies. They were considered a "worldly entertainment." I begged her to let me go, and to my surprise she finally gave in. I asked her why she changed her mind, and she said with a grin, "A wise man'll change his mind, and a fool never will."

I was so happy to be going that it mattered not at all what the movie was.

As it turned out, I really enjoyed my first time at the movies. "Green Grass of Wyoming" was playing, with Burl Ives. While watching the screen, I wondered if I should be feeling sinful, but I didn't, not one bit.

Chapter 29

MOM'S CHOPPERS

The year was still 1950, and I want to talk about Mom's false teeth before I go on to another era.

She had gone toothless for years when she heard of a dentist in Branson who would make the dentures quite a bit cheaper than the average dentist. So she decided to get a set of choppers. That is exactly what they were. Now we all know you get what you pay for, as a rule. This incident proved that old saying to be valid, because the teeth never fit correctly. Even after several visits to the dentist for adjustment, they still fit and looked awful.

Mom had a very difficult time getting the money together for one set of teeth, so she definitely couldn't afford another. Consequently, she just went back to her old toothless ways.

People would ask, "Mary, where are those

new teeth?" Her answer was, "At home in a bowl, they fit better there."

Mom always had a ready answer to a question that was put before her.

A friend came to our house one day, and Mom was dressed rather sloppily. The lady said, "Mary, I've seen you looking better." My mother's comeback was, "Well, I'm not runnin' for office nor huntin' a man."

Chapter 30

ON THE OUTSIDE LOOKIN' IN

In the fall of 1950, I began my freshman year of school at Hollister, Missouri.

I was never really one of the "in" girls, because our religion didn't allow participation in many of the school's social functions. Another reason my social life was lacking was because of the way I had to dress.

Many of the girls wore blue jeans, rolled up to about mid-calf. I yearned for a pair of these. Believe it or not, sometime during the winter, I talked Mom into buying me my very first pair of blue jeans. In our faith, pants or slacks were considered male attire and unaccepted. I think Mom used some logic in allowing me to wear the blue jeans because they didn't expose too much skin, and they were warmer than stockings which were long and a drab brown color. The other girls wore colored knee socks, in shades of red, blue, green and yellow, to match

their dresses. Mom was afraid I would catch a cold with my knees exposed. I now have the ability to understand that, but I was lacking that quality then.

Mom drew the line when it came to wearing shorts or bathing suits. It was a sin to expose too much skin. This rule kept me from joining the volleyball team, even though my desire to do so was strong. The girls wore those cute little short outfits for sports, and I just knew that I would have looked good in them. But I didn't even try out for the team because I would have had to wear long pants. I felt that I would look like a black duck in a pond of swans.

Please don't think that I resent my mother for these things, I really do not. She was just doing what she thought was right, but I really hated being an odd-ball. I guess maybe I was somewhat foolish, but things were then as they are now. It's important for teenagers to be able to dress closely comparable to their friends and fellow classmates.

Sometime in the early spring of 1951, Mom consented to allow me to buy my first tube of lipstick. Man, was I "with it." The shade of my new lipstick was "Dither." You can imagine how

much that lip color meant to me, I still remember the name after forty-three years. The price of my valued lipstick was thirty-nine cents. My vanity was once again appeased.

For our "High School Coronation," I was chosen from my class to be the Freshman Princess. My nephew, Robert (Ezra's son) was chosen to be the Freshman Prince. I can only assume the reason they chose a relative was because Robert was a very likable person and, too, he was very handsome.

I was allowed to attend the coronation and the banquet, but I couldn't stay for the dance that followed. Missing the dance was sort of like being deprived of a special dessert you've looked forward to, after a wonderful dinner. And I love desserts!

The coronations were comparable to the homecoming events of today.

Being the youngest of my family, with brothers and sisters so much older than I, some of my nieces and nephews were my age or older.

One by one, all my brothers had moved to

the Hollister School area. Since I have five brothers and Bill wasn't married yet, four sets of nieces and nephews were going to school with me. Dan's daughters, Wynema, Evelyn and Shirley were all close to my age, so we enjoyed each other's company very much.

Asa's sons, Roger and David, were just the right age to love to tease me. An instant example is when they would call me "Aunt Wilma." This form of teasing produced in me a blushing form of embarrassment. I don't know why that bothered me so, because today I'm proud that I'm their aunt.

Three of Perry's kids were in school with me: Richard, Virginia and Dale. I don't remember them teasing me, but Dale was always telling funny stories and jokes. Virginia was a dear friend in school, as well as at home. Virginia, Asalee (Asa's daughter) and I spent hours playing together. We dreamed a lot about what we wanted to be when we grew up. For the most part, I think most of our dreams turned out to be only fantasies. But we're all healthy, with nice families, so I feel that is the important thing.

Chapter 31

THE JONES SCHOOL HOUSE

When I was very small, one of our homes was very close to the Old Jones School House. During the time of this story, a school building served many purposes, and for this school, church services was just one of them.

This small structure was located in the Lampe, Missouri, area, somewhere in the vicinity of what is now H Highway.

My dad pastored this church for a time. I do not know how long.

While we were living there, a family by the name of Harryman came to visit us. The father of this beloved family was a Minister of the same faith as my family. Reverend Harryman was every bit as strong in his faith as my father, and just as reverent.

While they were there, Reverend Harryman

held a revival at the school house. This enabled us to get to know this family very well. And they are a lovely family.

I'm sorry to say, our shanty was too small for the Harrymans to stay with us, so they camped out near the school/church.

When the revival was over and they went home, we seldom saw them. They lived in Oklahoma, and if Dad didn't have a spiritual calling for a certain place, we didn't go.

A CHILD BRIDE

The year was 1951, long past the days when we lived close to the Jones School House. We were then attending the Bowman Church, which was located a few miles from Blue Eye, Missouri. It was at this time when a wonderful surprise was given to us by Chloe and Erma Harryman, two of the daughters of Reverend Ernest Harryman and his precious wife Alta. These two ladies had come to our church to hold a revival. Erma was the preacher, but Chloe sang and played the guitar. Erma also possessed both of these talents. They also sang duets. They made a great team, and their close-

ness continues as they live in the Branson and Hollister area with their families today.

Erma's and Chloe's revival extended to a longer time frame than they expected, so their youngest brother Hugh (better known as Junior) came to visit them. He was twenty-two years old, and I thought he was the most handsome man I had ever seen.

For a girl of fifteen, I was very mature in body, if not in mind. Also I wasn't too bad-looking, for a hillbilly. When Junior asked me for a date, I was elated. Because I was so young and he was seven years older, I was sure Mom would refuse to allow me to date him. Again Mom surprised me by saying yes. She respected his family so much, she felt safe about permitting me to go out with him.

We had gone out several times when Junior asked me to marry him. He told me he wanted to move me to California where we would live the good life. In my fifteen years of living, I had only been in three states: Missouri, Arkansas and Oklahoma. So the thought of going to California sounded very exciting.

Many fifteen-year-old girls think they know it all, and I was no different. I soon discovered

that I had an awful lot to learn, and learn it I did. Most of it the hard way.

My freshman year of school would not be completed, because I was in love. I dropped out of school a little more than a month before the school year ended.

My fifteenth birthday was April tenth, 1951. Eighteen days later I was the blushing teen-age bride of Ernest Hugh Harryman.

Junior took me shopping and bought me my first pair of heels. They were navy blue platform snake-skins. They had ankle straps and four-inch heels. Mercy!

My wedding ensemble consisted of a navy blue skirt, a white blouse and the blue shoes. Something old, something new, something borrowed and something blue. The something old was no problem. The new was taken care of with the shoes, the blue with my skirt and the shoes, and the borrowed belt was loaned to me by my two future sisters-in-law, Erma and Chloe. The belt belonged to both of them, so I figured this would assure extra good luck.

What a sight I must have been wearing those heels. I probably walked like I had put

down a few drinks.

Junior looked exceptionally good in his dress slacks, white shirt and brown print tie to co-ordinate with his slacks.

We were ready to head for the altar, so on April twenty-eighth Junior drove me, my mother, Chloe and Erma to Harrison, Arkansas. However, our altar was absent because we were married in the County Court House by a Justice of the Peace.

Our wedding vows were short and sweet, and when I took mine, I was so nervous I stammered I d-d-do.

I know fifteen seems awfully young to get married, but the people of our area thought nothing of it. All my brothers and sisters were married very young as well.

I'm not sure, but maybe not having a television set and the lack of extracurricular activities may have prompted early marriages. There was nothing else to do, why not?

After our elaborate wedding, Junior took me home to get a few of my belongings. We were

planning to spend our honeymoon with my new Mother and Father-in-law. Their home was just a short distance from Jay, Oklahoma. So I gave my mother a poignant good-bye and left the little home that I had shared with her for five years. I knew I would miss her, but I felt very adult at that moment. So off we went, on our way to Oklahoma.

My stay in the Harryman home was very pleasant. Everyone made every effort to make me comfortable. They accepted me with open arms. Their warm ways made me feel like they were truly my family.

This was such a relief for me, because at the time of our wedding I hadn't met all of Junior's relatives.

Our stay with the Harrymans lasted for two weeks, at which time Junior decided it was time for us to move to California. He had received word that my brother Bill was moving his family to the gold rush state, so this was a great opportunity for us. Since we didn't own a car, we could ride with them.

As soon as we could get our things packed, I said good-bye to my new family, my mother and my beloved hills. And we were on our way.

A TEENAGE BRIDE

She raised her arms and stretched and yawned
A new day to begin,
The promise of a new life,
A promise she would win.

So out of bed she slowly climbed
To see the rising sun;
She told her mom she hates to leave,
But school just ain't no fun.

Clothed and dressed, her hair just right,
She waited patiently;
Arriving soon would be her groom,
A wife she soon would be.

She entered in this new life;
She walked as if she knew
Exactly how to do all things;
She didn't have a clue.

But strive she did to learn to be
A mother and a wife;
She quickly gained experience
In her new way of life.

— By Wilma Groves Harryman

Chapter 32

JUST OUT FOR A DRIVE

Ah, the open road. We were on our way to the land of oranges, grapes and redwoods.

Even though I was sad to be moving two thousand miles away from my mother, I was with the man with whom I intended to spend the rest of my life, so I was happy.

As we drove through Arizona and New Mexico, I was awestruck by the vastness of the desert. While growing up, the majority of the countryside I had seen was tree-covered hills. While I prefer the hills, the desert has its own distinctive beauty.

We were lucky to be able to travel to California with my brother Bill, his wife Ruth and their little daughter, Carolyn.

We chatted and played road games, anything to help pass the long, tiring miles.

Junior told me, when I was four, he held me on his knee. This was when they were visiting us at the Jones School House. Small world, but I think he enjoyed me more at fifteen than he did at four.

That trip seemed to get longer and longer. I began to think, "California must be at the end of the earth."

With Junior and Bill taking turns driving, we were able to travel day and night. after four days and three nights of traveling, we finally arrived in sunny California. Poor darling little Carolyn was worn to a frazzle. That trip was hard on me, so I can imagine what it must have been like for a baby.

Our destination was a small town named Keyes. This small jerk-water town is located only a few miles south of Modesto.

Bill and Ruth, Junior and I shared the rent on a two-bedroom house. As it turned out, our rental-sharing was short-lived because Bill and Ruth decided to move to Oroville, California.

Junior and I stayed on in the Keyes house for several months before moving.

After settling in to our first home, Junior's first objective was to find employment.

I have to hand it to him on this score because he was never out of work for very long.

His first job in our new area was working for the railroad. A hard, grueling way to make a living, but he was always a strong, dependable employee.

TEEN-AGE CURIOSITY

I think it's quite normal for a teenager to be curious about certain things that they have always been denied and taught against. I was no different.

I wanted to try smoking because I had never had a cigarette in my mouth. One day I got the chance, because when Junior went to work he forgot his cigarettes. Perfect! I could do this without anyone watching or laughing at me.

I lit up and sucked the smoke in and thought to myself, "What do they see in this?" But I was not to get off that easily. Junior came home early from work and smelled the smoke on me and got as mad as a wet hen.

He said, "Don't you ever let me catch you smoking again!" After a lengthy lecture from him, I vowed I would never again try smoking. Thank you, Junior. I am so delighted that I never acquired such a filthy habit.

YOUTHFUL MOTHER

My teenage years were quite unique,
My personal life somewhat oblique;
My time was spent a havin' children,
A nursin' them, their strength a buildin',
And by the time my house was tidied,
Another baby needed didied.
Well, bless my soul, I'm goin' crazy,
Lord knows I have no time for lazy.
I do the wash, I cook the meals;
At times I think that nothin's real,
But when you're young as I was then,
You hold an ace down deep within;
My youthful ignorance helped me through,
And now I'm here to share with you —
Life is fuller when you wait,
It's better to anticipate.

— By Wilma Groves Harryman

Chapter 33

A TEEN WIFE AND MOTHER

Only three months after we were married, I became pregnant with our first child. I was one lucky little expectant mother because I was never bothered with morning sickness. You see, Junior was gallant enough to do this for me. He got out of bed each morning with a weak stomach. He said he had sympathy illness. This was new to me, I had never heard of such a thing. But I accepted this gift without argument.

For some time after I knew I was going to be a mother, the only food Junior wanted me to prepare was soup. He said it was the only thing his stomach could handle. When I think back on this, I wonder if his limited appetite was due to my awful cooking. Then, too, I've wondered if maybe my cooking was the basic cause of his weak stomach, although I'm glad to say that he survived without repercussions.

He loved to tell people about his "morning sickness" and was relentless in teasing me about my cooking. I must admit, it was almost inedible. Even my own taste buds told me so.

Moving two thousand miles away from her family can be quite an experience for a fifteen-year-old girl who has hardly been out of the sticks.

Having come from the hills, I was so-o-o bashful. Junior had a field day with this. He loved to see me blush, and one of his favorite ways to bring this about was to tell people, "I bought Wilma her first pair of shoes, and she walked ten miles backward lookin' at the tracks." When he was injected with his shot of orneriness, I wanted to become an ostrich and bury my head in our abundance of sand. However, I think this sort of teasing might have helped me to overcome my backward ways.

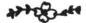

On my sixteenth birthday, April 10, 1952, I gave birth to a beautiful eight-pound, one-ounce girl. Junior named her Brenda. She had blue eyes, and if you looked closely, blond hair.

Now I know some girls get a coming-out

party on their sixteenth birthday. Well, instead of being introduced to society, I was introduced to motherhood, and Brenda had the coming-out party. I am certainly not complaining though, because she is, without a doubt, the very best birthday gift that I have ever received. Much better than a party, although during labor and delivery I might have questioned that last statement.

By this time, Dad and Mom Harryman had moved to California. These two beautiful people were so very gracious to invite me and Brenda to stay in their home while I was re-cuperating from childbirth.

Junior took us to their home directly from the hospital. We got plenty of tender loving care. I wasn't allowed to help with anything. I will always cherish the love and kindness which they bestowed upon Brenda and me.

I was very fortunate in having such good in-laws. I will never forget Dad Harryman saying to me, "Wilma, I'm going to give you some roses." His roses were compliments, and I simply loved them. They always made my day, and they never faded or wilted.

I think his compliments began when he re-

alized that at the age of sixteen, I was trying very hard to be a mom, although I was definitely not ready. Mother Nature was a great assistant because she accelerated that old motherly instinct, and I did all right.

Dad and Mom Harryman became second parents to me. They always made me feel happy to be a part of their family.

My mother-in-law was a wonderful cook. One Thanksgiving we were visiting them and she made her wonderful pumpkin pies. While they were baking, she opened the oven door to check on them. She turned to me and said, "Hmmm, I think something is wrong with my pies. Oh, I know what it is, I forgot to put the pumpkin in! Oh, well, I guess we'll just have custard pies."

She was always busy doing something. She loved to putter in the kitchen, and "that" is where we could usually find her.

Dad Harryman enjoyed talking about the Bible. Everyone would be sitting around listening intently to this man of God speak with his knowledge of this sacred book.

During a pause, he would notice that his "better half," as he referred to her, was in the kitchen working. He would say to her, "Martha, come on in here and join us."

His reference to his wife as Martha came from the King James version of the Bible, New Testament, Saint Luke, Chapter Ten, verses thirty-eight through forty-two.

Verse 38:

Now it came to pass, as they went there, he entered into a certain village, and a certain woman named Martha received him into her house.

Verse 39:

And she had a sister called Mary, which also sat at Jesus' feet, and heard his word.

Verse 40:

But Martha was cumbered about much serving, and came to him and said, "Lord, dost thou not care that my sister hath left me to serve alone? Bid her therefore that she help me."

Verse 41:

And Jesus answered, and said unto her, "Martha, Martha, thou art careful and troubled about many things:"

Verse 42:

"But one thing is needful, and Mary hath chosen that good part, which shall not be taken away from her."

I'm sure that in no way did Dad Harryman intend to place a bad reflection on his dear wife. He simply enjoyed having her near.

Alta Erma Butler Harryman was a sweet, mild-mannered lady, who was a person of few words. But her presence was the true embodiment of tranquility. Quite often too many words can transform a peaceful atmosphere.

Mom Harryman was one of the Blue Eye/ Oak Grove Butlers. She was a sister to Neily, Verdie and Verlie Butler.

The latter aforementioned three, never married. They took care of their parents until their deaths. Then they lived on in the home place until they all went on, one by one to an even better home.

These people were very special. They adored Junior, and when we visited them, we received great hospitality. I loved being in their home.

RECEPTIVE LOVE

A second set of parents
I received in fifty-one;
These two people came to me
The year I wed their son.

Not every girl is lucky
To have in-laws quite this good;
They opened up their hearts to me,
As in their arms I stood.

The love they emanated
Would warm your heart and soul;
The contentment and the peace they gave
Brought happiness untold

My second father said to me,
"Please listen when I say
Some roses I will give to you
To brighten up your day."

Those roses were nice compliments,
Much better than a flower;
Wilt or fade they never did
From this man of faith and power.

My second mom she gave me thoughts
To hold throughout the years;
She offered comfort and her love
When I had cause for tears.

So I will always treasure
The gifts they gave to me;
They welcomed me into their lives
With perfect harmony.

— By Wilma Groves Harryman

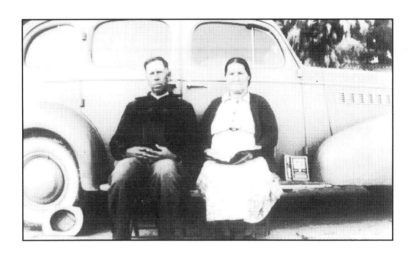

Ernest and Alta Harryman,
sitting on the running board of their 1937 Buick.
Photo taken in 1938.

Chapter 34

MOVIN' ON

In 1952, the Harryman family had moved to Visalia, California. You guessed it, we moved there, too. Cotton pickers, that's what we were. The good life.

They all seemed to be extra good at this job. I would work a little while, then I watched their hands move from cotton boll to cotton boll. The hands that moved the fastest belonged to my husband. He worked so fast that I got too tired to work just watching him. And, too, those thistle-like cotton bolls were torture. Needless to say, I was absolutely worthless in the cotton fields. We were paid by the pound, and if we had relied on my wages to feed us, we would have starved to death.

From Visalia, we moved to Fairfield, California, where Junior had acquired a carpentry job with the Teamsters Union.

In one of the windiest areas that I have ever been in, we rented a place from two elderly Italian gentlemen, where we would live for one year.

Junior jokingly teased me about having extracurricular activities with these gentlemen while he was at work.

Just a couple of months after we moved to Fairfield, I became pregnant again with our second child.

Weighing in at seven pounds and one ounce, Debra June came into the world on December 10, 1953. And wouldn't you know it, she was born with lots of dark brown hair. Junior couldn't wait to say, "See I told you so, her real father is Italian." Only I know the truth about that. All kidding aside, there is no way the wind could have carried the Italian pollen to my door. I have another alibi, just in case that one didn't fly. Many of Debbie's behavioral habits and her facial features are much like her Grandmother Harryman's.

After bringing Debbie home from the hospital, a package arrived. I opened it with excitement and anticipation. It was from Chloe and Erma — Junior's sisters. I removed from the box the softest, prettiest hand-appliqued and

embroidered pastel-colored baby nighties. Also, a tiny white dress trimmed in baby blue. This darling garment had tiny pockets in the front, with the baby-blue trimming hand-stitched around them. Such a loving, thoughtful gift, I will never forget it.

A few months before Debbie was born, we moved from Fairfield to Keyes, California, where our third daughter was born. Junior and I were the proud parents of yet another darling girl who weighed eight pounds, three ounces. We named her Alta Frances for her two grandmothers. We nicknamed her Francie. I gave birth to Francie on September 20, 1955. At that time I was the mother of three daughters and still only nineteen years old.

I must have been young enough to enjoy playing with dolls, because I had so much fun dressing my little girls. As a child, I didn't spend a lot of time playing with dolls, so when I got my daughters I made up for lost time. There was one big difference in dolls and my daughters. Dolls don't cry, but I was so young I think I had nerves of steel. This fact made my mothering job easier.

In July of 1957, I realized I was expecting yet another child. At this point it seemed to me

I had been nursing a baby and changing diapers forever. Needless to say, I was very depressed about the whole situation.

Only a short while after I discovered I was pregnant, an awful tragedy befell our family, the "Harryman family," to be accurate. Junior's brother Frank was in a terrible motorcycle accident. He was critically injured. We prayed earnestly for his recovery, but he lived only six days before he died. My thoughts were, "It's true, the good do die young."

This terrible, heart-wrenching loss made me realize that my problems were extremely minor. From that day on, I looked forward to the birth of my fourth child.

After three daughters, I think Junior was beginning to fear he wasn't going to father a son. But on March 3, 1958, he lost all of his buttons when I gave birth to an eight-pound, twelve-ounce boy. I was very proud myself. My only son. He was and still is very special. But then they all are.

We named our son for his father, my father and my brother Dan. Danny Hugh was almost bald at birth, but I was later to discover that he was the only one of my children who would

inherit my natural curly hair.

I was then the mother of two blond daughters, a brunette daughter and a blond, curly-haired son. And they were all absolutely perfect. What more could a mother want?

Each time I gave birth, I snuggled that sweet bundle close to my body, and I knew I had done something very special.

Just one month and seven days before my twenty-second birthday, I had completely finished my child-bearing years.

This was not your typical teen and early-twenty lifestyle, but it was mine.

On my twenty-first birthday, instead of celebrating with a drink, I had a shot of milk.

I was either too much in love or I was too young and ignorant to realize that I was missing all the normal activities that a girl of my age usually enjoys. But at any rate, I molded to my way of life with the resilient ability of my youth.

I was up early to begin my daily chores. I

comprised myself a schedule, and I lived by it. Otherwise I simply couldn't have gotten everything done. First I made breakfast for my babies, then washed the dishes. The next job on my schedule was to bathe my sweeties. Then I dressed them.

As they grew and began to play outside, the bathing procedure was repeated at night.

The remainder of my day continued as would be expected.

I was always very proud of my children. Consequently, another of my mother's sayings could have pertained to me ... "Every old crow thinks her little crow is the shiniest." I'm sure many parents feel their children are the prettiest or the most handsome darlings in the whole world, and I was no different.

I can't begin to understand how being a mother could be a position that anyone would not appreciate. The rewards are unlimited ... the adoring, grateful looks they give you, the snuggling hugs and love that are more precious than diamonds. The little handmade gifts given with smiles and pride and the little statement, "Mom, this is for you." I cannot count the times this scene was replayed, and each time tears

of love and appreciation came into my eyes.

I've heard women say, "I can't wait 'til they're grown so I can do whatever I want." I am so happy to say I never felt that way. In fact, I dreaded for my children to grow up because I simply wrapped my life around them. I was worse than a mother hen. Poor things, it's a small wonder I hadn't suffocated them.

GUIDANCE

To be a child in need of love
Without a strong command
Can lead to lonely, willful ways
And souls adrift like sand.

A child needs tender, loving care
To nurture him along;
He should have a guiding hand
To make him brave and strong.

He knows the rules and tries to follow,
But times they are a changin';
To follow rules and have fun, too,
Requires much rearrangin'.

—By Wilma Groves Harryman

A PRAYER OF LOVE

She arose from her chair
With a look of deep worry;
Then to their bedside
She silently hurried.

She reached out her hand,
Her love to bestow;
She bent with a kiss,
Her face now aglow.

With the love she has shown,
She silently prays,
"Lord, please give them safety
And guidance each day."

— By Wilma Groves Harryman

Chapter 35

MANAGEMENT VERSUS DISCOURAGEMENT

At the ripe old age of twenty-two, I was really beginning to get into domesticity.

Junior's sister Ila had given me some fabric, from which I was to make my little girls some dresses, but I had somewhat of a problem. I had no sewing machine. I had never learned to sew, but I thought it was time to start learning, sewing machine or not. I really wanted to use that fabric, so I decided firmly that I would make those dresses.

After making up my mind to sew, my second decision on this subject was to learn the way my mother did, by designing and making my own patterns. With three girls to sew for, I knew I wouldn't be able to afford a different pattern each time I wanted to make them a garment. So I thought this method would be rewarding.

At night, after the children were asleep and all was quiet, I traced a mental picture of making a pattern. The next morning, before the picture faded, I put my plans to work.

I designed a style, measured the girls and drew my pattern on newspaper. I cut out the pattern pieces and pinned them to the laid-out fabric. I then cut the dress pieces and sewed them together by hand. My first sewing attempt was surprisingly good, considering.

I appreciate Ila for giving me the incentive to learn to sew. She was so pleased with the dresses that she bought more fabric for me.

A few months later, Junior came home and announced that he was going to a sale to buy a gun. That statement put me out of sorts in a hurry. I said, "Junior, I need a sewing machine a hundred times more than you need a gun. I have this fabric that I need to make the girls some dresses out of, and I certainly don't relish the thought of sewing them by hand." He left the house just a little bit irritated, but he got no sympathy from me, because he already owned guns.

Junior came back about an hour later without the gun. In the back of his pick-up truck

was the prettiest sight I had seen (in material things) in a long while. He had gone back to the sale and bought a Singer treadle sewing machine, instead of the gun. I was pleased with the man that day.

From then on I made most of my children's clothes. By designing and making my own patterns, I decided it would simplify sewing matters if I dressed the girls alike. After making one pattern, all I had to do was adjust the sizes for the other two. This method not only made the sewing easier, but the ironing even seemed to go faster.

Using the same fabric as their dresses, I made the girls drawstring purses. I used a small oatmeal box for the base of the bag. I cut the box in half and covered it with the fabric. I sewed matching drawstrings and ran them through the pre-sewn slot which was just above the top of the box. They swung those little purses with pride.

Another of my economical resources was as follows: I would rip Junior's worn-out jeans apart and use the backs of the legs to make little jeans and jackets for Danny. I put a watch pocket on the jeans and did the extra stitching on the hip pockets. They were cute, but the

fabric looked a bit strange because I used the wrong side of the denim. In the early sixties, pre-washed jeans weren't in, and I wanted the jeans to look as new as possible. So I used another of my mother's money-saving methods. People would say, "Wilma, where did you find that kind of denim?"

As the girls got older, I made their party dresses and formals. And I continued to make most of their clothes, although they put a stop to the triplet look. I think this aversion occurred in their pre-teen years.

I know it probably appears that I'm bragging, and maybe I am a little. But in actuality, I'm describing "survival management, necessitated by need which was overcome by perseverance utilized to counteract discouragement."

Chapter 36

MEMORIES

Our children's growing years were the most wonderful time of our lives. So many tender thoughts come to mind when I think of my children's youth ...

Brenda (at a very young age) becoming angry with her father if he so much as spoke to another woman ...

The night (in her teens) when she twinkle-toed across the floor, using our bed-roll as a dancing partner. As she danced, she sang, "I'll go a waltzin', Matilda, with you." That bed-roll was a much used item in our household. It was an original "Wilma Creation." I made it by sewing denim pieces together to form a top and a lining. I had taken a thick layer of cotton out of an old sofa we were throwing away. This I used for the padding for the bed-roll. It was placed between the lining and the top and tacked together with yarn, to prevent the cot-

ton from shifting. Then I hemmed the edges.

After Brenda's dancing episode, our bed-roll was dubbed "Matilda."

Matilda came in very handy when the children had sleep-over friends.

While our children were teenagers, we lived only a short distance from the Merced River.

Danny was about eight or nine at this time. He loved to fish, so when he could get one of the older neighbor boys to go with him, he would spend a lot of time on the riverbank.

When he left the house to go to the river, I loved to watch him saunter down the dirt road. In his little hands he carried his tackle box, fishing pole and his minnow bucket. Lord, he was cute. He usually brought home three or four little fish. He had a special place in the back yard where he cleaned them. When he was finished with the gory details of cleaning the fish, he brought them in the house, and I washed and cooked them for him. As I watched him devour his fried catch, I knew the fish tasted even better because he was the one who had caught them.

I think it's fairly normal for a child to lie to their parents. I'm guessing that Danny didn't want to be different because when he broke Junior's whetstone and his father asked him if he did it, he said "no."

After committing two consecutive sins, I suppose he thought the best thing to do would be to hide. He chose the grape vineyard (which was very close to our house) for his hide-out. I don't know how long he would have holed up there if Junior hadn't threatened to spank him if he didn't come out. So out he came, with his little head hanging low. Oh, the love I felt for the little fugitive at that moment.

DENIAL

Dad said, "Who broke my whetstone?
Danny, was it you?
I can't believe it's broken,
I really need it, too!"

He stood with watery eyes
And answered with a sigh,
"No, Dad, I didn't do it,"
Uh, oh! A wrong reply.

The vineyard offered refuge,
So off he went to hide,
To sit and wait and worry,
His time he had to bide.

Dad utilized his master's voice
And said, "Come out of there
Or on your butt I'll nary leave
A freckle or a hair."

So out he came with head hung low,
Such pain I felt inside;
He walked toward his chastisement,
His innocence denied.

I knew he'd made an error,
For sure he knew it, too,
But when you're only four year old,
Such things a child will do.

Written for my son, Danny

— By Wilma Groves Harryman

MY SON, THE FISHERMAN

His taste buds whispered to him,
"I'd love some fish to eat,"
So off he went to water's edge
To seek a fond retreat.

He swaggered down the dusty road,
His tackle box in hand;
He held his fishing pole with pride,
A lunker he would land.

He walked on to the river
And sat upon the bank;
He sat there lost in boy thoughts
While hook and bait he sank.

His young heart beat a happy tune,
While on his face a grin;
His limit caught, he heads for home,
This precious boy of ten.

When he was safe and sound at home,
His catch he chose to clean;
I watched him in his earnest work,
These memories still remain.

For my son, Danny

— By Wilma Groves Harryman

Then there are the memories of their little funerals for their bemoaned animals, with Brenda leading the procession and each of them with a bouquet of wild flowers or a fist full of weeds (depending on the time of year the animal lost its life) in their precious hands. The tears they shed for those animals were induced by sincere love.

With warm appreciation, I remember how much they loved my cooking. (I had improved by this time.)

I have memories of Debbie at the age of three when there were many nights that she kept us awake, trying to learn to whistle. Night after night, she practiced her pucker, and then one night that whistle that she had worked so hard for came out loud and clear.

Little did I know that this would prove to be a pattern in her life. Today she continues to possess the quality of perseverance. If at first she doesn't succeed, she tries and tries again.

Debbie, our Debbie, our only brunette. She was also the epitome of neatness. She enjoyed having everything in place, at all times. She tried to share this quality with everyone else.

She has relaxed somewhat in this department, but she continues to be very organized.

At her Homecoming festivities, Debbie was the senior attendant. She was a beauty in her green velvet gown.

Francie was our happy-go-lucky daughter. She was always the comedienne in the family. She had a very quick wit and was a true pleasure to be with. These are just a couple of her charming traits.

She was and is generous to a fault. She would gladly give away her last dollar if someone needed it. Her giving nature could have been inherited from several different relatives.

Francie was usually easy to get along with, but if she was provoked enough, it was — Katy bar the door. In high school, she was a protector for her sisters and friends.

My teenage daughters were a true joy. I probably enjoyed them even more because I was young. We sort of grew up together.

I loved their eagerness to learn and their

feminine enjoyment of always looking their best. My mother instilled in me a pride in personal appearance, no matter how meager the amount of possessions. I tried to pass this on to my children, and it seems I was successful.

There is no greater love on earth than the unconditional love a mother has for her children. A word of advice, don't hurry their growing years. Cherish every moment because these years are gone far too quickly. The times when I had all my children with me were the happiest and most wonderful years of my life.

There are so many precious moments I hold dear to my heart. Some things one doesn't put on paper.

While raising our children, there were many times that I wished for my mother's wisdom. I sincerely wish that I could have spent more time with her. To have learned half of what she knew would have been a major achievement. She died on December 3rd, 1963, but her memory will always be with me.

A SPECIAL GIFT

"All right, all right, already,
Just let me out of here;
My mom's birthday is coming
And I really must be there.

I'm sick and tired of swimming,
Someone open up the gate;
Her birthday is tomorrow,
And I simply can't be late.

I'm her sixteenth birthday gift;
She thinks today's the day,
She'll be surprised when I arrive,
I'll hear her shout hooray!

Good-bye, my tiny swimming pool,
I can finally breathe fresh air,
But I'm just a tiny bit ticked off,
Doc spanked my derriere.

Don't you think it's really something,
I'm so very proud to say,
I gave Mom such a darling gift
On this our special day."

Composed for my daughter,
Brenda Harryman Worden

— By Wilma Groves Harryman

THE APPLE TREE

She's come a long way since the days
She climbed the apple tree
To sit and think of future's lot,
My daughter pure and sweet.

We all need places we can go
To get inside our minds;
The apple tree was Debbie's place,
My daughter sweet and fine.

When she needed solace,
She found the apple tree;
She shinnied up with sure-fire speed,
My daughter needing peace.

While growing up, she didn't think
About the trip back down,
And now she fears no more that trip,
She's safely on the ground.

Composed and written
for my daughter,
Debra Reed

— By Wilma Groves Harryman

HER MANY FACES

She's small and petite
And so very sweet;
She's happy, she's sad,
And sometimes she's mad;
She's sweet, she's contrary,
Her enemies be wary;
Her heart's in her hand
To betray her commands.
She hides all her pain
With the love that remains,
And when she feels sorrow,
A star she will borrow,
A wish she will make
To her sorrow forsake.
A smile she will wear
With the love I hold dear;
She's good from within,
My daughter, my friend.

Composed and written
for my daughter,
Francie Lucas

— By Wilma Groves Harryman

REVEALING FACTS

So many revelations
Are offered parents late,
When their children are all grown,
Their paths to separate.

So many parents choose to think
Their child is so guilt-free,
But when the children are all grown,
They tell all cheerfully.

"Now, Mom, I know you didn't know
I smoked that cigarette
Or had that drink of vodka
And broke the rules you set."

When they have children of their own,
I'm sure their time will come
When they will pay for their mistakes
With their children's secret fun.

— By Wilma Groves Harryman

After my children grew up and with time, needed me less and less, I became somewhat lost. It seemed all my life I had been a mother. Then with fewer and fewer motherly chores to carry out, I asked myself, "Now what do I do?"

The temporary situation was to get an outside job (outside the home, that is).

I chose an elite position. Due to the fact that I had become a mother at the age of sixteen, I wasn't trained for anything except being a housewife, mother and seamstress. My occupational options were very limited, so I went to work in a chicken processing plant. What an awful job! Nonetheless, I stayed with it until I departed the state of California, four and a half years later.

Chapter 37

GOING BACK TO MY ROOTS

A new life was in the making for me. For twenty-one years, I had been a wife and mother. Even though I would never cease to be a mother, things were to change drastically in my life.

The year was 1972, and our marriage was ending, so I decided to move back to the hills from whence I came (the Ozark hills).

My marriage, at such a young age, had prevented me from getting a proper education. I had been domesticated for so long that I wasn't trained for earning a living.

My first destination in Missouri was Hollister, where I stayed with my sister-in-law Chloe, her husband Dick Barker and their small son Keith.

I was lucky in finding employment, almost

immediately. Dick found the job for me, and I was so happy, not only because I really needed to work, but Ye Old English Inn was in walking distance of where I was staying.

This beautiful old hotel is located on Downey Street in Hollister, Missouri.

From where I worked, I could see the school that I had attended as a youngster.

My first job as a single lady consisted of cleaning rooms, working in the restaurant, being a go-for and for whatever else I was needed.

I'm sorry to say, my job was short-lived because the Inn was sold and closed temporarily, for the transactions and improvements. The new owners were very vague about when they would reopen.

From the information I could gather, it appeared that I would be out of work longer than I could afford. So I found the need to seek employment elsewhere.

While I was unemployed, I moved. My brother Asa and his wife Chloe invited me to stay with them until I found the apartment for which I was searching.

When I left the Barker home, I gave them my grateful thank you and hoped that they knew how much I appreciated their hospitality.

Staying with Asa and Chloe was a true pleasure. They were as good to me as the Barkers were. I spent more time with them, at this time, than I had in my whole life.

I found a job rather quickly, but I had no transportation, so Asa would drive me to work. Now this was too much to ask of anyone and, too, I was always taught not to ride a free horse to death. Due to my need of transportation, Asa was kind enough to drive me around to different used car lots. At the first lot we visited, I found a car that I liked. The salesman went with me for a test drive. I was just about sold on the car, and then I tried to talk him into bringing down the price. He blatantly told me that he would let me have the car at a good reduction "for a price." As you may have guessed, I cleaned up his cheap, bargain basement statement, considerably. The car wasn't worth the price I would have had to pay for the reduction, so we went to Springfield where I bought a car. My first "very own" car.

My new place of employment was the White Frog Restaurant, which is now the China Gar-

den. While working at the White Frog, I acquired some excellent waitress training. I learned how to serve food and wine in an elegant fashion.

The training I received would aid me in the vocation that would support me for the next ten years.

I lived at my brother's country home until I found an apartment — my niece Billie had just graduated from the College of the Ozarks and was preparing to move out of her apartment, so I rented it.

Again I left my good Samaritans and hoped that they were aware of my appreciation of their kindnesses.

My apartment was nothing to write home about, and to top that statement, it was above a grocery store. But I kept it clean and tidy.

It was while I was living there that I spread my wings for the first time in my life. You might say, after twenty-some years, I was finally living my teen years. As is the case with teens, I made mistakes along with my fun. My advice to all very young girls who are considering marriage ... wait, enjoy your youth. Have your fun at the age that was meant to be. You

will make mistakes, you're only human, but it's wise to be aware of the danger signs; thus many of those mistakes can be eliminated.

I had been in Missouri for three months when Debbie came to live with me. She had just graduated from high school and was the only one of my children who could join me in my beloved hills.

Brenda was in college, Francie was planning to be married, and Danny chose to stay with his father.

Each time I thought of them, sadness engulfed me. So I was very happy when Debbie came to live with me.

A short while after Debbie's arrival, her best friend from her school years, Kathy White, came to share our apartment. Kathy has since been married to Gary Koop, and they live in Ava, Missouri, with their two sons, Aaron and Gabriel.

Kathy and Debbie continue to be very good friends.

Both girls dearly love the hills of Missouri and don't have a desire to leave them.

In the summer of 1974, Debbie was married to a Kansas City man, Tim Reed. Together they have two lovely children, Crystal and Brian. Tim and Debbie are divorced now, but they remain friends. I think this fact is so wonderful. I'm also very pleased with the fact that Tim has always been very good to me.

Both Debbie and Tim live in the Lampe area. They live about five miles apart. Debbie received her teaching degree from the College of the Ozarks and is now teaching at Blue Eye School, where Brian attends. Crystal is attending her mother's Alma Mater and is majoring in photo-journalism.

I'm happy that I have at least one of my children living in Missouri. I miss my family in California so very much, but I visit them most every year.

Brenda married her high school sweetheart, Bill Worden. They gave me two beautiful grandchildren, Austin and Chelsea. Bill has been a wonderful husband and father.

Francie married Gene Lucas, and together they had four children: Gene, Debbie, Christo-

pher and David. Francie's immediate family all live in California, but she and Gene are divorced.

Danny gave me my fourth daughter when he married Audrey Elliot. She is such a fine lady. She has made Danny a wonderful wife, and she is a perfect mother to their three offspring, Valeria, Jacob and Jason.

Together my four darlings and their spouses have given me a total of eleven grandchildren. And to add icing to the cake, in November of 1993, Francie's daughter Debbie gave me great-grand twin girls, Micah and Sarah.

I thoroughly enjoy being a grandmother. Life is good!!!

ANOTHER DAUGHTER

She offers them a guiding hand;
She's always on the go;
She exudes love with efforts warm,
While dashing to and fro.

Her life is filled with family needs;
She sparkles from within;
Her family's love is dear to her;
She's a wife, mother and friend.

Her patience almost endless,
Her tolerance thus to aid,
She's found when giving of her love,
These things will be repaid.

If I had chosen for my son
A girl his love to offer,
She'd be the one I would select;
She is another daughter.

For Audrey Elliot Harryman

— By Wilma Groves Harryman

MY GRANDCHILDREN

While in her early middle years,
She knew time would unfold,
When children of her children
Would fill her heart and soul.

One by one they've entered
To bless all of our days,
Each one with different attributes,
Each one with special ways.

Their parents watch them grow and learn,
They nourish them with love;
Soon they will know the joy we know
With children of their love.

Grandchildren are to be enjoyed,
Her love for them is strong;
With their precocious, smiling ways,
They fill her life with song.

— By Wilma Groves Harryman

LOVING THOUGHTS

There's a time in our lives
When we all come of age
And wonder where the time went;
Then we ponder the years
When our children were small
And know the time was well spent.

We remember the days
When they reached for a hug
Or a simple word of praise.
The love in our hearts
Could fill a lifetime,
Back then when their love
Made our days.

Now they're all grown
With families to raise;
We live through the joys
That they know
When their little ones say,
"Grandma, you know
That I love you so";
Those sweet words
Just make my face glow.

— By Wilma Groves Harryman

Chapter 38

MATURITY AND SCHOOL

In the spring of 1983, I was beginning to be somewhat discontented with my life. I had a feeling I needed to be doing something to improve myself, so I started night school and got my G.E.D.

My test scores were high enough to credit me with a scholarship, which the very thought of using completely exhilarated me.

Because I had ten years of food service experience under my belt, my G.E.D. teacher thought I should get a degree and go into the Hotel, Restaurant Management field. So she went with me to Crowder College in Neosho, Missouri, where I registered for this particular course.

My G.E.D. teacher introduced me to the college counselor, who made arrangements for me to be a Dorm Monitor or Room Mother, as this

position was referred to at this particular college.

I would live in the dormitory and make sure that all boys were out of the girls' rooms by ten o'clock and that the girls hadn't inebriated them before they left. In general, my job was to let them know that they were being monitored to be kept in line, yeah, right! That's like moving Russia to Missouri. All in all, though, they weren't that bad. In fact, I had a lot of fun with them.

In return for being a Room Mother, I received my room and food. To say the least, not a bad trade.

I thoroughly enjoyed my two years as a forty-something co-ed. Several academic courses were required for me to get my degree of Applied Science. I took American history, two English courses, a math class, an accounting class, psychology, several science classes, a speech class, homemaking courses and, of course, several cooking classes.

I graduated in May of 1985, with honors. As I left Crowder College, fond memories went with me.

Chapter 39

JOB HUNTING
RESUME IN HAND

Before leaving college, my advisor had told me, the bigger the town, the better the job. So I thought Saint Louis would prove promising. My sister Avie was living in Saint Clair (forty-five minutes from St. Louis) at that time. She invited me to live with her until I found the job I wanted.

We both searched the want ads, and she found one that was worded something like this: "Wish to hire Nanny for two little girls. Room and board and car furnished. Excellent salary and good benefits. Please call _____.

Avie anxiously showed me the ad, but I'm afraid I wasn't very excited about being a Nanny, so I said, "No way!"

I had gone to school for something totally different, and I sincerely wanted to use my de-

gree.

I found a waitress job at a very nice restaurant in Eureka, Missouri, and I took the position with the promise of an Assistant Manager's position, as soon as an opening occurred.

My job was brief at this establishment. To explain would be akin to gossiping, so I won't go into it.

After quitting my job, I went home and answered the ad for the Nanny position. I was in luck; the job was still open. I made an appointment with Mr. William Franke, the father of the two girls for whom the Nanny was needed. The interview went well, and I got the job. That same evening, I met the two beautiful little girls whose care would be entrusted to me. Courtney was six, and Christin was three.

Just a few days later, Mr. Franke sent his secretary, Diane Dishon, to guide me to my new home. Diane has been a friend, counselor and, in general, a wonderful help to me.

I settled into my new home with comfort and ease, although the year to follow would prove to be a trifle shaky for me.

I learned you don't just take children and make them love and accept you overnight. I needed to prove myself to them.

For the most part, Courtney seemed to accept me right away. She was aware of the fact that I was needed and too, she has always been mentally mature for her age. Christin, on the other hand, didn't like me. It took a long time for her to warm up to me. Now over eight years later, we have grown very close, and I'm confident of their love and trust. The thought of ever leaving them tugs at my heartstrings.

Tammi Renfrow was a live-in Nanny for the Frankes when Courtney was a baby.

After leaving the household, she worked on the air at a Saint Louis radio station. Her radio name is Tammi Rush.

She has remained a friend of the family, and she still adores the girls, as they do her.

Even though Tammi is several years younger than I, she has become one of my dearest friends.

I find it really quite fascinating the way the hand of fate provides so many different turns in the road of life.

One of these turns in life's highway connected me with a lady whom I hadn't seen since my high school freshman year.

Wanda Holland and I were in the same class. We were never really close friends in school, but now with the passing of time I feel that I have been reunited with a very valuable friend.

If the bouquet of life consisted of friends, you'd want it never to fade. So each day you live, value your friends, and your bouquet will be made safe.

COURTNEY

She goes to school, she studies hard,
She keeps those grades right up there;
Oft' times exhaustion clouds her brain,
But for her classes she prepares.

Her ways are fun to recognize,
Her smile it lights the way,
Her eyes are pools of wondrous dreams
To guide her long pathway.

She says, "Dad, it's cold hard cash I need,
Can you spare it, Daddy, please?"
And Dad just stands there smiling,
He's often quite a tease.

Then he opens up his wallet
And says, "Now let's not splurge";
She sidles up to him and grins,
Then comes the loving hugs.

This girl has been a friend to me,
She's loyal through and through;
How fortunate you would be also
To have a friend like her for you.

Composed for My Oldest Charge
Courtney Franke

— By Wilma Groves Harryman

CHRISTIN

When first I met this child of three,
My trust she did not know;
On days of imperfection,
Her temper chose to show.

Her grammar lacked a bit of shine,
But Courtney knew the code;
She taught me how to understand
With patience that she showed.

Since those days of speech classes,
She's grown to a sweet age,
As day by day I earned her trust
And watched her grow and change.

She is a kindred spirit now,
Our friendship ever growing;
Her beauty shines from deep within,
Her kindness always showing.

Composed for My Youngest Charge
Christin Franke

— By Wilma Groves Harryman

EPILOGUE

A lot has happened to me over the years. There have been rough roads as well as smooth, and I've lost my way a few times. But I traveled those roads, and now they seem straighter and my way seems clearer.

The year is 1995, and I'm still with the Frankes, and I hope to be with them for a long while yet.

I have many, many relatives, and to those of you whom I didn't mention in this book, I love all of you, and you will always be in my heart.

• THE HARRYMAN FAMILY RECORDS •

THE PARENTS
James Ernest Harryman
 Born: June 24, 1892
 Died: April 6, 1971

Alta Erma Butler Harryman
 Born: March 15, 1888
 Died: November 14, 1960

SONS AND DAUGHTERS

Ila Inez Harryman Thompson
 Born: June 21, 1912
 Died: March 11, 1984

James Isaac Harryman
 Born: September 28, 1915
 Died:

Chloe Audrey Harryman Barker
 Born: February 24, 1920
 Died:

Joel Franklin Harryman
 Born: March 6, 1923
 Died: June 20, 1957

Erma Ernestine Harryman Downs
 Born: August 2, 1925
 Died:

Ernest Hugh Harryman
 Born: November 28, 1928
 Died:

• THE GROVES FAMILY RECORDS •

JOHN'S FIRST MARRIAGE
John Daniel Groves
 Born: April 29, 1884
 Died: June 28, 1946

Lula Garland Groves
 Born: December 18, 1887
 Died: August 16, 1907

SONS AND DAUGHTERS

Howard Groves
 Born: August 12, 1902
 Died: May 8, 1971

Mary Elizabeth Groves Pace (Meke)
 Born: January 15, 1904
 Died: November 7, 1959

Jocie Groves
 Born: February 10, 1906
 Died: October 14, 1908

Joel Franklin Harryman
 Born: March 6, 1923
 Died: June 20, 1957

Erma Ernestine Harryman Downs
 Born: August 2, 1925
 Died:

Ernest Hugh Harryman
 Born: November 28, 1928
 Died:

JOHN'S SECOND MARRIAGE

John Daniel Groves
> Born: April 29, 1884
> Died: June 28, 1946

Mary Frances Groves
> Born: February 15, 1892
> Died: December 3, 1963

SONS AND DAUGHTERS

Asa Amos Groves
> Born: July 28, 1910
> Died: March 26, 1993

James Daniel Groves
> Born: November 23, 1912
> Died: September 1, 1983

John Etna Groves
> Born: May 1, 1914
> Died: November 13, 1914

Still-Born Baby Not Named
> Born: May 23, 1915

Still-Born Baby Not Named
> Born: January 21, 1917

Louis Ezra Groves
> Born: May 17, 1919
> Died: August 16, 1980

Perry Lee Groves
> Born: October 14, 1922
> Died:

Naomi Ruth Groves Norris
>Born: April 2, 1925
>Died: February 26, 1973

Grace Avenell Groves Roark
>Born: February 27, 1928
>Died:

William Sylvester Groves
>Born: April 22, 1931
>Died:

Wilma Ilene Groves Harryman
>Born: April 10, 1936
>Died:

BROTHER AND SISTER OF JOHN GROVES

Oscar Groves
Edna Groves

BROTHERS OF MARY AMOS

Ed Amos
Frank Amos
Etna Amos
John Amos
George Black

FAMILY REUNION

We come from near and far away
Our relatives to see;
Each year we try to reunite
And check the family tree.

We talk about old Father Time
And how he marches on;
We speak of days that soon will come
And days already gone.

Our faces somewhat different,
Our bodies rearranged,
These things we have to live with,
Some things we cannot change.

It's great to see our loved ones;
While we chat away the time,
Our minds drift back to days of yore,
Our youthful thoughts to find.

It seems each time we gather
One less face we see;
We speak of how we miss them,
This leaf from our family tree.

Mother Nature has a method
Of taking care of things;
For everyone that's missing,
Another she will bring.

— *By Wilma Groves Harryman*

SENILITY

When I am old and all alone
A talkin' on the telephone,
A rockin' in my favorite chair,
A wonderin' where I put my hair,
My teeth are restin' in a dish;
If I could have but just one wish,
I'd wish that all the parts of me
Could be the way they used to be.

—*By Wilma Groves Harryman*